Winter's Hawk

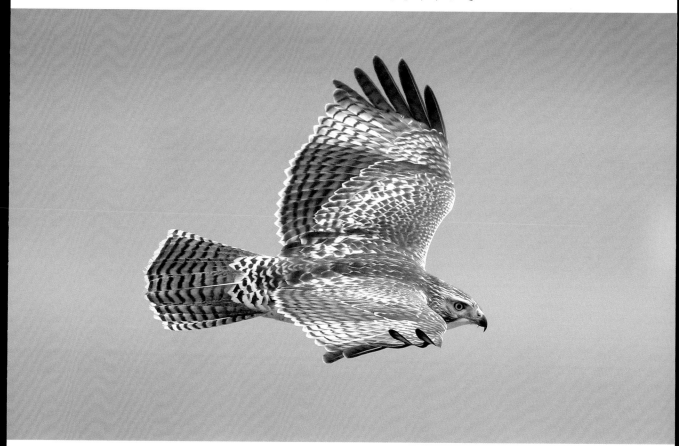

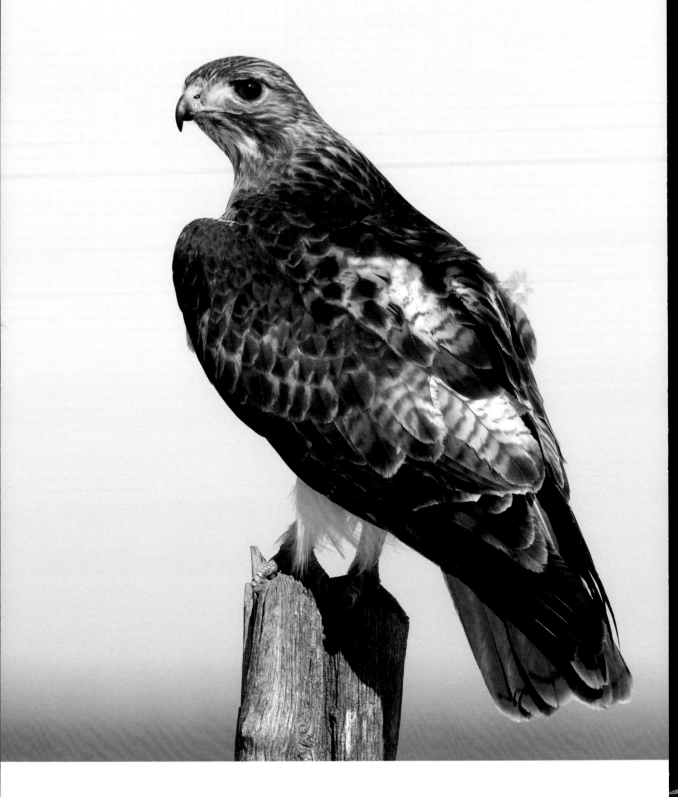

Winter's Hawk
Red-tails on the Southern Plains

Jim Lish

University of Oklahoma Press : Norman

Unless otherwise noted, all photographs presented in this book are by Jim Lish.

Library of Congress Cataloging-in-Publication Data
Lish, Jim, 1947–
 Winter's hawk : red-tails on the southern plains / Jim Lish.
 pages cm
 Includes bibliographical references and index.
 ISBN 978-0-8061-4835-9 (pbk. : alk. paper)
 1. Red-tailed hawk—Oklahoma. 2. Red-tailed hawk—Oklahoma—Pictorial works. 3. Hawks—Oklahoma. I. Title.
 QL696.F32L57 2015
 598.9'4409766—dc23
 2014044264

The paper in this book meets the guidelines for permanence and durability of the Committee on Production Guidelines for Book Longevity of the Council on Library Resources, Inc. ∞

Copyright © 2015 by the University of Oklahoma Press, Norman, Publishing Division of the University. Manufactured in Canada.

All rights reserved. No part of this publication may be reproduced, stored in a retrieval system, or transmitted, in any form or by any means, electronic, mechanical, photocopying, recording, or otherwise—except as permitted under Section 107 or 108 of the United States Copyright Act—without the prior written permission of the University of Oklahoma Press. To request permission to reproduce selections from this book, write to Permissions, University of Oklahoma Press, 2800 Venture Drive, Norman, OK 73069, or email rights.oupress@ou.edu.

1 2 3 4 5 6 7 8 9 10

The following images appear uncaptioned on the pages noted:

Page i: A young Red-tailed Hawk in perfect plumage arrives on the Oklahoma prairies for the winter. It will not begin to get its red tail until the second spring of its life.
Noble Co., Nov. 14, 2014

Page ii–iii: A resident adult Red-tailed Hawk in eastern Garfield County shows that piercing stare of confidence so characteristic of these noble predators.
Feb. 5, 2011

Page v: A young Red-tailed Hawk, with two of the sharpest eyes on the prairie, studies the grass for a meal.
Noble Co., Nov. 14, 2014

Page vi: Adult Fuertes Red-tailed Hawk.
Grant Co., Dec. 10, 2011

Page viii: Only split seconds away from plucking a cotton rat from the grass, a young Red-tailed Hawk flares its wings to slow itself for impact.
Noble Co., Nov. 28, 2014

Page 1: With legs lowering near the end of its long descending trajectory from a high hunting perch, this young Red-tailed Hawk is focused like a laser on its intended prey.
Noble Co., Nov. 28, 2014

Page 2: These two young Red-tailed Hawks are hanging stationary in the teeth of a stiff wind above a grassy hilltop where they frequently hunt.
Noble Co., Nov. 29, 2014

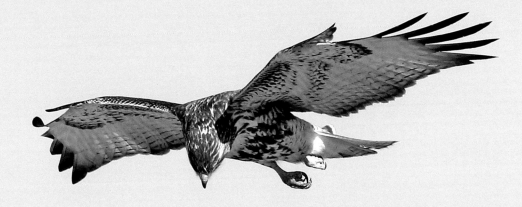

The following individuals and organizations have provided generous financial support for the publication of this book:

Bent Arrow Veterinary Hospital

Bob, Emma, and Maria Bollinger

Central Oklahoma 89er Chapter
 of Quail Forever

Indian Nations Audubon Society

Iowa Tribe of Oklahoma

Megan Judkins

Oklahoma City Audubon Society

Oklahoma Falconers Association

Oklahoma Ornithological Society

Oklahoma Leopold Education Project

Osage Nation

Payne County Audubon Society

Playa Lakes Joint Venture

Raptor View Research Institute

Rocky Mountain Bird Observatory

Victor and Lisa Rubidoux

Gary and Rhonda Sallee

Steve Sherrod

Gary Stewart

Student Chapter of the Wildlife Society,
 Oklahoma State University

Sutton Avian Research Center

Tulsa Audubon Society

Wild Skies Raptor Center

Zoo and Exotic Wildlife Club, Center
 for Veterinary Health Sciences,
 Oklahoma State University

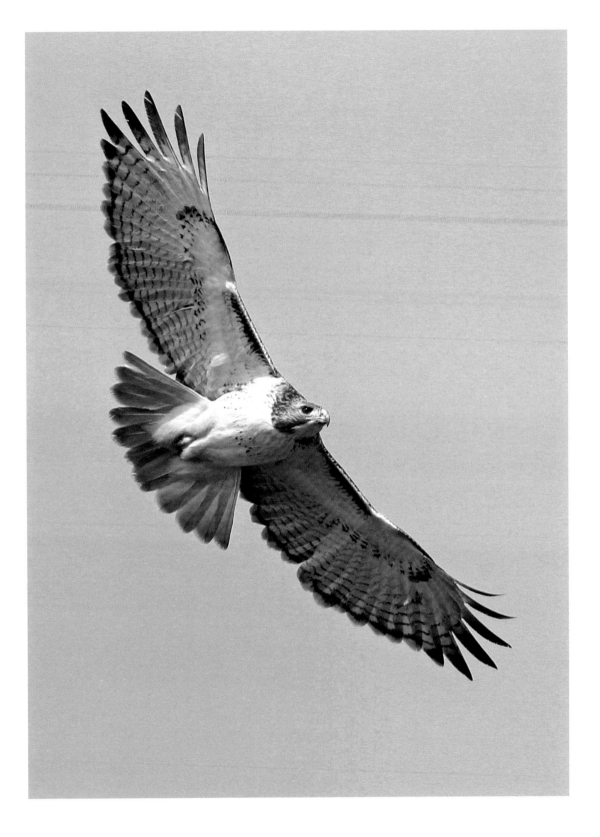

Dedicated to
George Miksch Sutton

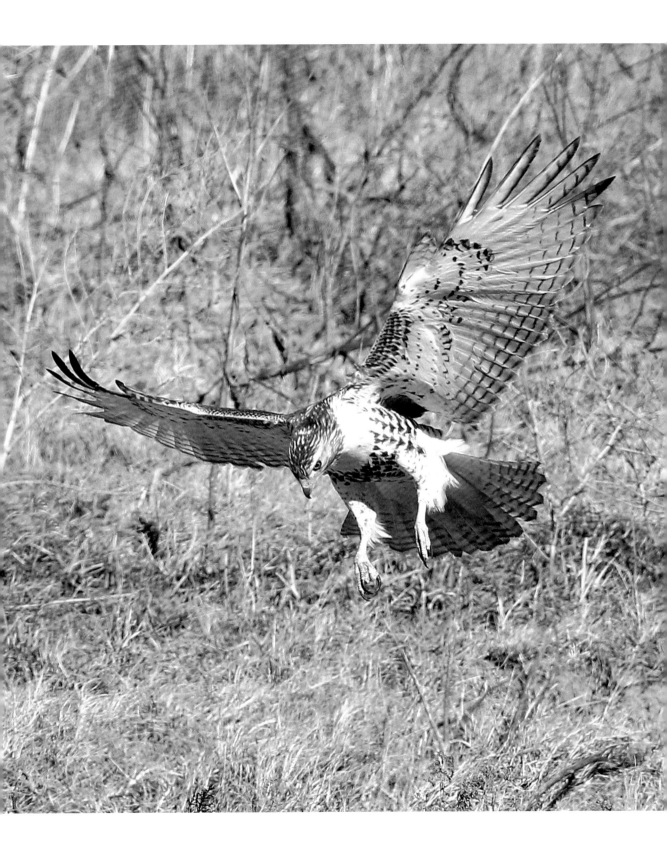

Contents

Preface xi

Acknowledgments xvii

Sweeping Down the Plains 3

The Prairie Food Chain 15

Growing Up a Hawk 35

No Arrow Can Reach Him 47

The Defiant Red-tail 51

Red-tailed Hawks and Northern Bobwhites 53

The Amazing Diversity of Red-tailed Hawks 55

Before Tails Turn Red 59

Meet the Locals 65

Eastern Red-tailed Hawk: Buteo jamaicensis borealis 73

Western Red-tailed Hawk: Buteo jamaicensis calurus 79

Harlan's Red-tailed Hawk: Buteo jamaicensis harlani 85

Krider's Red-tailed Hawk: Buteo jamaicensis kriderii 97

White Red-tailed Hawks 102

Hawks and Hawkscapes: A Gallery of Wintering Oklahoma Red-tailed Hawks 105

Winter Hawks on a Changing Prairie 157

Selected References 161

Index 163

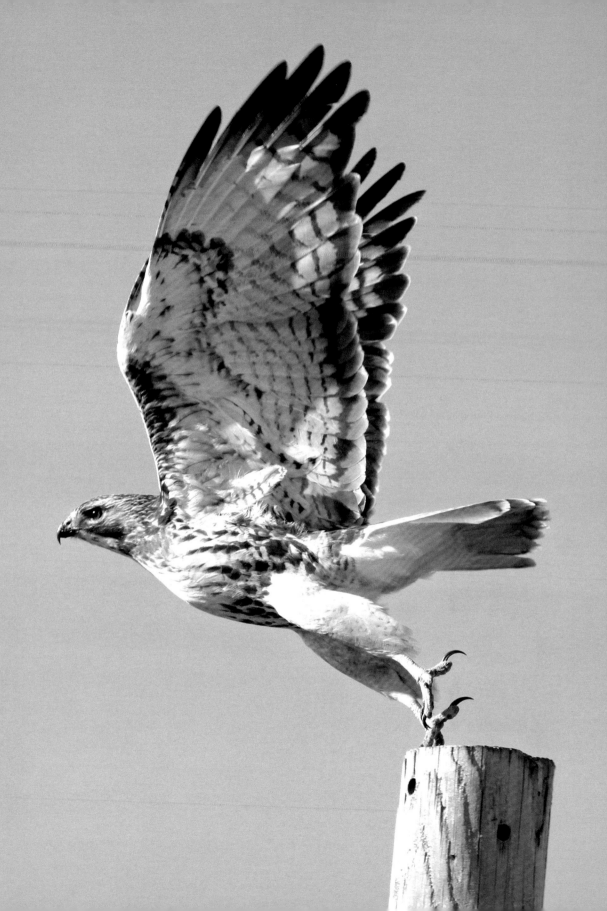

Preface

Leave it to a songwriter and not a biologist to vividly link the prairies of Oklahoma with the Red-tailed Hawk, like Oscar Hammerstein did with the familiar "lazy circles" image he draws in our minds every time we hear our state song. I am fairly certain most people might not at first think of the Red-tailed Hawk in these terms, but one could make an argument that this bird is as much a symbol of the prairies of Oklahoma as are the bison or the American Indians that once roamed a sea of grass drawn out from horizon to horizon. The unbounded herds of bison and the ancient horsemen have vanished into legend and history, but on today's landscape the image of a lone Red-tailed Hawk perched atop a distant cottonwood set against a desolate winter sky is a glimpse into the past—a scene that has changed little since the

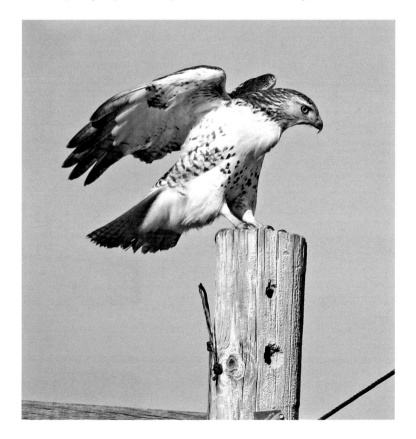

(Opposite) An adult Eastern Red-tailed Hawk taking flight from its hunting perch.
Pawnee Co., Jan. 15, 2012

Although it is such a common bird, the Red-tailed Hawk's natural history is not well understood by the general public. Studies from across North America have shown it to be highly beneficial.
Garfield Co., Nov. 18, 2010

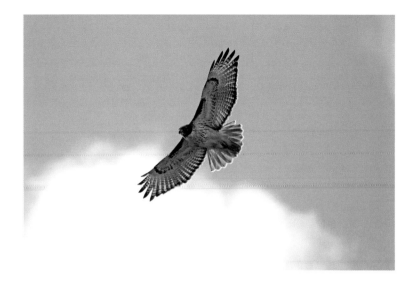

A soaring Red-tailed Hawk tracing lazy circles across a winter sky is a familiar sight on the prairies of Oklahoma.

Grant Co., Nov. 13, 2010

howl of the wolf and the chants of the Osages were heard on the Oklahoma prairies.

In winter, Red-tailed Hawks (*Buteo jamaicensis*) are a common sight along Oklahoma's back roads and its bustling highways. We take seeing high numbers of them for granted, but travelers from other areas passing through this part of the country in winter are often awestruck at the sheer numbers of them perched on poles and posts—sometimes several per mile. I remember once in the 1980s heading south to Oklahoma on the Kansas Turnpike at Wichita and seeing a sign prominently posted near the tollbooth saying "No

Wintering Red-tailed Hawks are conspicuous and abundant along Oklahoma's back roads and highways during most years.

Noble Co., Jan. 28, 2011

hawk watching." Apparently there were so many hawks that they had become a dangerous distraction for some interstate travelers.

The official name "Red-tailed Hawk" is often shortened to just "Red-tail." In early fall thousands of them begin to wing their way down the plains to spend the winter in Oklahoma. Obviously these visitors from the north do not intentionally, through some unknown instinct, choose to settle within the boundaries of a particular state. In fact, there are high concentrations of wintering Red-tailed Hawks throughout many areas of the southern United States, but the southern Great Plains, with its mosaic of grasslands, agriculture, and scattered trees, plus its generally mild winter climate and high availability of prey animals, is one of the best places to see wintering Red-tails.

Although the Red-tailed Hawk is an extremely beneficial and valuable part of Oklahoma's diverse wildlife heritage and is protected by both state and federal laws, old prejudices steeped in ignorance still linger and die hard. It was not uncommon in the days prior to the passage of protective legislation for wildlife that the slain carcasses of hawks of all kinds, but particularly those of Red-tailed Hawks, could be seen by the hundreds hanging from barbed wire

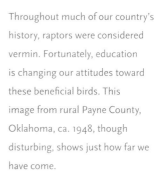

An adult Red-tailed Hawk flashing its trademark. Studies conducted on the tallgrass prairies of Oklahoma have shown that population densities of wintering Red-tailed Hawks are some of the highest recorded anywhere in North America.
Payne Co., Nov. 18, 2010

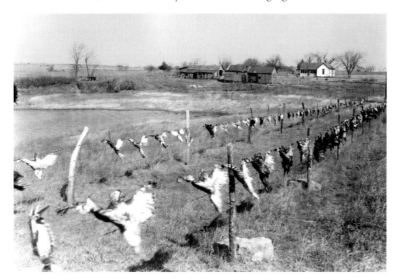

Throughout much of our country's history, raptors were considered vermin. Fortunately, education is changing our attitudes toward these beneficial birds. This image from rural Payne County, Oklahoma, ca. 1948, though disturbing, shows just how far we have come.
Image courtesy of the Oklahoma Cooperative Fish and Wildlife Research Unit, Stillwater, Okla.

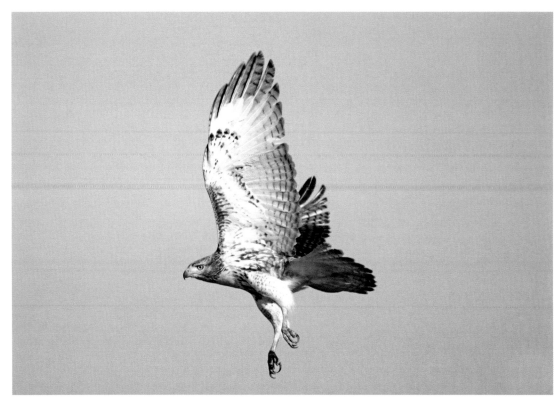

Red-tailed Hawks taking flight from their roadside hunting perches can be easy targets, and unfortunately, even with state and federal protection, many are killed each year.
Noble Co., Jan. 19, 2009

fences. Branded as "chicken hawks" or "buzzards," these beautiful birds were regarded as vermin; feathered rats to be disposed of with the reach of a twelve-gauge whenever they were encountered. Unfortunately, Red-tailed Hawks make easy targets and are hardly a challenge for any marksman. Gradually, beginning in about the 1930s and continuing to the present, public education explaining the beneficial nature of raptors and highlighting their beauty has slowly taken hold. But much work remains. Although the gruesome pictures of fences adorned with these slaughtered birds are mostly a thing of the past, the shootings continue, even if less blatantly advertised. The Red-tailed Hawk is hardly endangered and is in fact one of the species that has managed to benefit from some human activities. It is nonetheless still persecuted, and this senseless killing of Oklahoma's wildlife is not only wasteful, it is also shameful and illegal.

The information in this book has been gained in large part from more than fifty years of observing Red-tailed Hawks on the tallgrass prairies of north-central and northeastern Oklahoma. I grew up hunting, fishing, and exploring these prairies in Ottawa County with my brother and father, so naturally I have long had an attraction to them. Unfortunately these beautiful grasslands are represented today by only small remnant patches; mere relicts of their once

impressive expanses. Relicts or not, even in their modern fragmented state they are magnets for winter hawks. However, much of what I have learned about these hawks on these grasslands will certainly apply to other areas of the southern Great Plains. One thing I know after many years of studying Red-tailed Hawks in Oklahoma is that for such a familiar bird they are poorly understood by the average Oklahoman. My goal therefore is to provide an easy-to-read, nontechnical book of interesting facts from the life histories of wintering Red-tailed Hawks so that Oklahomans might better understand them and be motivated to promote the conservation and appreciation of these beautiful and beneficial birds. I am also hoping that my professional wildlife biologist colleagues, even those who have studied Red-tailed Hawks for many years, will find it useful.

In addition to having interesting lives, Red-tailed Hawks are stunningly colorful, though this is seldom revealed in our frequent roadside glimpses. There is perhaps no better way to display their beauty than through modern digital photography, which reveals them up close in a way that no spoken or written words can do. So, to accompany the text I have included numerous photographs of Red-tailed Hawks, both up close and in natural settings on Oklahoma prairies. These images of Red-tailed Hawks accentuating Oklahoma landscapes, or "hawkscapes" as I call them, remind us that these birds are

The tallgrass prairies of Oklahoma are mere relicts of this once vast ecosystem, but even in their modern fragmented state with a heavy invasion of trees they are magnets for wintering raptors. The heavy unburned fuel load of built-up prairie grasses—as shown here—powered raging, frequent, and widespread prairie fires in the days prior to settlement.

Noble Co., Mar.12, 2014

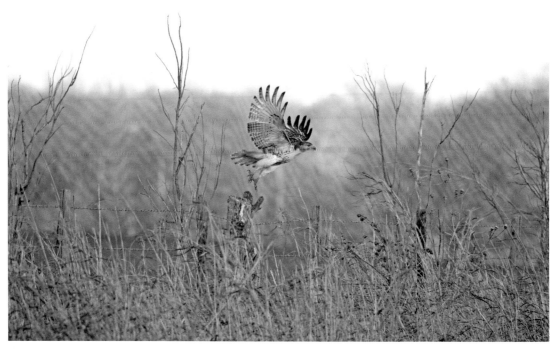

Brief roadside glimpses seldom reveal the beauty of these conspicuous winged predators.
Noble Co., Feb. 7, 2009

part of a unique region. They also give people from other areas of the country a flavor for Oklahoma winter hawk watching, which is some of the best anywhere. A picture of a hawk against a blue sky will look essentially the same a century from now, but images of hawks set in the landscapes of rural Oklahoma will, I hope, provide a viewer of the future with a valuable window into Oklahoma's past.

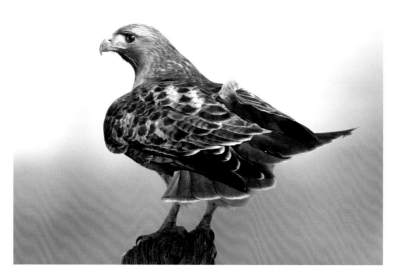

Adult Red-tailed Hawks are strikingly beautiful when viewed up close, as shown by this resident bird.
Noble Co., Nov. 27, 2011

Acknowledgments

In 2009 the idea of writing a small regional raptor book tailored to the average Oklahoman seemed like an easy pick of a low-hanging fruit and a refreshing change from the rigid writing format that almost everyone in science eventually finds tiresome. Five years later I realize the little book that seemed so easy then was somewhat higher on the tree than it first appeared, and I owe thanks to those who have helped make it reachable.

Many people in my personal life and professional career have been supportive and encouraging, and without them I might still be pumping gas in Miami, Oklahoma. I am indebted to no one more deeply than to my wonderful wife, Lurinda Burge, who has walked many a mile with me through the prairies and woods of Oklahoma and, more importantly, through life. Along that way with her I have enjoyed every step.

In the professional realm, there are three people who saw in me during my younger years something I did not see in myself. First, James Lewis, mentor for my master's degree in wildlife ecology at Oklahoma State University, patiently taught me the skills of a professional biologist. The solid scientific foundation he inspired and cultivated has served me well through many decades. Second, George Sutton was for this young bird artist and biologist a remarkable inspiration, so much so that this book is dedicated to him. Without his generosity my research on wintering Bald Eagle ecology, the first in Oklahoma, would not have been possible. Third, I am especially grateful for my friendship with Fritz Knopf. Our paths first crossed when I began my doctorate at Oklahoma State University. Both Fritz and I were ornithologists who saw birds as part of the landscape and, in a very elemental sense, inseparable from it. Of course most trained wildlife ecologists naturally think that way, but because of Fritz, I have, over the years, held that idea in the forefront of my photography and art. The bird as part of the prairie theme began to show up in my drawings, which Fritz took note of and encouraged. The roots of this book in many ways were sprouted during frequent long conversations with Fritz, which spanned many topics but always came back around to birds and landscapes. I am very grateful for the help and encouragement he has given me throughout our long friendship.

When it comes to explaining the bewildering variation in plumage shown

by Red-tailed Hawks, no one, in my opinion, sorts it out better than Jerry Liguori. Jerry has tackled this confusing topic with determined objectivity. In recent years he has contributed more to our understanding of this interesting aspect of Red-tailed Hawks than anyone I know and has shared this knowledge with others through his books, publications, and blogs. When I want, as I frequently do, the best objective opinion of where one of our wintering Red-tails might have come from or what type it might be, Jerry is the first person I count on. I would like to thank him for being a reliable and helpful correspondent and colleague.

I would like to give special thanks to Meic Stephens, copyright owner of the poetry of Leslie Norris, for giving me permission to quote from Leslie's poem "Buzzard."

I would also like to extend my appreciation to many others who have assisted in manuscript editing, lent constructive advice, helped acquire outside funding, and accompanied me on surveys. These include: Debbie Atterberry, Patty Baker, Bryan Bedrosian, Bob Bollinger, Rob Domenech, David and Cathy Ellis, Sue Fairbanks, Don Glidewell, Dick Gunn, Fred Guthery, Larry Hancock, Kim Huckabee, Donald Kaufman, Glennis Kaufman, Dean Keddy-Hector, Robert Huber, Sheryl Kilpatrick, Lena Larsson, David Leslie, Tim O'Connell, Steve Platt, Charles Preston, Shane Rencountre, Cassandra Rodenbaugh, Victor Roubidoux, Jim Shaw, Steve Sherrod, Gary Stewart, Brian Sullivan, Charles Thompson, Megan Judkins, Susan Walker, Step Wilson, and Jason Zaun.

Finally, I would like to extend my appreciation to the staff at the University of Oklahoma Press. Special thanks go to Jay Dew, Charles Rankin, Steven Baker, Diane Cotts, Emmy Ezzell, Julie Rushing, Stephanie Evans, freelance copyeditor Laurel Anderton, and indexer Liz Coelho for their expert technical assistance, friendly guidance, and patience throughout the publication process.

Winter's Hawk

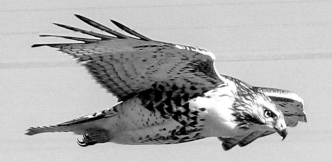
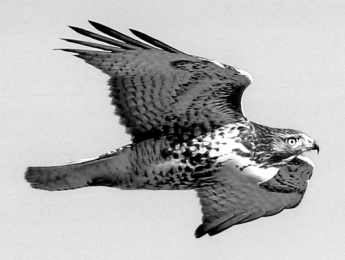

Sweeping Down the Plains

Birds are famous for their epic journeys. Aves, the name for this amazing group of animals, literally means "without a path." They are, more than any other group, free to wander wherever they wish. Great gatherings of birds always attract the human eye. The migrations of waterfowl, for example, were said to nearly darken the skies back when settlers first crossed the prairies. The influx of Red-tailed Hawks onto the southern plains every fall is perhaps not as spectacular as other bird migrations but is impressive nonetheless. It is especially exciting for hawk watchers who live where thousands of them settle for the winter.

Where do these winter sojourners come from? Except for Red-tailed Hawks that nest in the most northern regions of the United States, where winters are quite severe, including parts of Montana, Wyoming, North Dakota, South Dakota, Minnesota, Wisconsin, and Michigan, and the most extreme northeastern states, our wintering Red-tails come primarily from north of the contiguous forty-eight states. Our adult wintering birds are, in large part, visitors from Canada and Alaska. The thing Red-tailed Hawks covet most is their nesting territories, so if food is available they will stay put during winter, even as harsh winds blow and temperatures drop. Most of the nesting Red-tails in the United States do just that. However, the scarcity of prey in harsh northern latitudes during winter leaves most of those hawks with no other option than to drift south to the prairies of the southern plains, where prey is abundant and the winters are relatively mild.

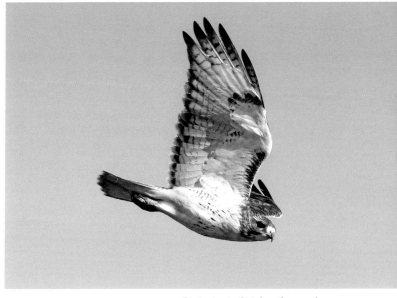

Beginning in October, thousands of Red-tailed Hawks wing their way to the southern Great Plains for their annual winter sojourn. Most of these birds originate from Canada and Alaska.

Noble Co., Oct. 29, 2011

The white bellies of our wintering Red-tails make them very conspicuous against the orange-tinted grasses.
Noble Co., Dec. 28, 2009

During most years, migrant Red-tailed Hawks begin arriving in Oklahoma in mid-October, but rarely some arrive as early as late September. Whether they just trickle in or come down en masse depends largely on the weather patterns and the availability of prey in their northern territories; abundant prey will keep Red-tails north longer. The most spectacular arrivals of migrant Red-tails into Oklahoma are seen when early-season Arctic fronts push south into the plains, with these drifters essentially surfing on the front edge. During some years a landscape nearly devoid of hawks can change overnight to one where as many as a dozen may be seen at once, their white bellies making them conspicuous against a blue sky, the dark margins of blackjack woods, or the orange grasses.

A good, fairly simple way to determine wintering Red-tail population ups and downs is to count how many hawks you see along a stretch of road, counting only those within a certain distance from it. If your route is long enough, and you count at the same time of day and follow the same routes for several years, you can learn a lot about their population trends and many other aspects of their natural history. Rural roads in Oklahoma lend themselves nicely to this type of survey. Usually results from these counts

are reported as the number of hawks observed per 1,000 kilometers (621.5 miles). It is not uncommon in Oklahoma to see 400–500 Red-tailed Hawks per 1,000 kilometers during peak months, but if conditions are optimum, for example when storm fronts push large numbers down the plains, 800–900 per 1,000 kilometers can be counted. In some areas of our state during fall and winter months they are really packed in. During a survey in November 2013 in Craig County, I counted 1,118 Red-tailed Hawks per 1,000 kilometers. In fact, Oklahoma has had some of the highest densities of wintering Red-tailed Hawks ever reported.

For the average person who wants to count hawks, a more convenient index than hawks per 1,000 kilometers is simply hawks per mile. If, over a long stretch through Red-tail country in winter you encounter on average 0.60 to 0.80 hawks per mile, you are going to enjoy some good hawk watching. If you find yourself above 1.0 per mile you are in Red-tailed Hawk Paradise. It is safe to say, especially in light of the proverbially acute vision of raptors and their high winter densities, that a human afield almost anywhere in the open prairies of Oklahoma in winter is most certainly under the watchful eyes of at least one Red-tailed Hawk.

Red-tailed Hawks employ a sit-and-watch hunting strategy requiring perches that will give them a good view of the area. This makes them very conspicuous, especially during winter. They are usually much less abundant in expanses of treeless prairie where no perches are available. The perches they prefer include trees, poles, windmills, fence posts, power lines, silos, billboards, road signs, round bales of hay, barns, abandoned houses, and towers—basically, almost anything elevated. Obviously these hawk-preferred perches have increased since settlement, especially trees, which before then were

Sweeping Down the Plains

wiped off the grasslands by fires. Except along rivers and small prairie streams, and in the Cross Timbers, an area of prairie intermixed with savannas of blackjack oaks and post oaks, the vast expanses of northern Oklahoma's prairies were essentially treeless. In light of this and the strong attraction Red-tailed Hawks have for elevated hunting perches, one wonders whether the plains of Oklahoma always supported such large numbers of wintering Red-tailed Hawks. We can only speculate. But one glimpse into the past was provided by Ludovic Kumlein, an early naturalist from Wisconsin who rode the rails of the Missouri, Kansas and Texas Railway from Fort Scott, Kansas, to Brazos County, Texas, in February 1876. During frequent stops in Indian Territory, Kumlein noted remarkably high numbers of Rough-legged Hawks (*Buteo lagopus*), a species that prefers treeless expanses, but he also noted that the Red-tailed Hawk "was nowhere uncommon" along the route of his winter journey. In view of what we have learned about the habitat requirements of the well-studied Red-tailed Hawk and how the landscape has changed in the last two centuries, it is reasonable to assume that these human-altered grasslands have provided many things to their liking and that the numbers of Red-tails wintering here these days might well be higher than they were in the days of the bison.

To anyone who has observed the wintering Red-tailed Hawks of Oklahoma over a period of years, whether they are biologists, bird lovers, or observant country folk, it becomes quite evident, and in fact almost impossible to miss, that when prey numbers are adequate many adult hawks from northern

Red-tailed Hawks employ a variety of hunting tactics, but their favorite is a sit-and-watch method that requires elevated perches and patience. It has the added benefit of using very little energy.
Grant Co., Dec. 2, 2010

latitudes come back to the same small area to spend the winter, sometimes for many consecutive years. One of the more interesting things about Red-tailed Hawks is how variable in appearance they are. Many have highly unusual and distinctive plumages, which makes certain individuals easily recognizable. Some are white, some are black, some have unique markings, and some are rare types that represent only a very small percentage of the winter population. Skeptics might say that without capturing and marking the individuals you can never be sure they are the same from year to year. However, recognizing individuals by their distinct markings is a well-accepted technique that is commonly used in the study of wildlife. What are the odds that a nearly completely white Red-tailed Hawk or one with pure white feathers mixed in with its normally dark plumage, which is observed sitting on the same perch, behaving the same way toward humans, and occupying the same few acres each winter, is not the same bird? And why would fidelity to winter territories be unique to these rare types and not to other adult wintering Red-tails that are not as easily recognizable from year to year?

Not only do wintering Red-tailed Hawks tend to come back to the same area each year, some adults of these rare types and other more common

Because of the strong attraction Red-tailed Hawks have for elevated hunting perches, tree encroachment on the once nearly treeless tallgrass prairies of Oklahoma, as shown here, has probably benefited Red-tailed Hawks. Early naturalists who explored Indian Territory during the nineteenth century left detailed descriptions of the flora and fauna and landscapes they encountered. Their descriptions attest to the rarity of trees on the open prairie except for an occasional isolated eastern cottonwood. However, the small forests that bordered the prairie streams and rivers were dense and harbored abundant wildlife.

Garfield Co., Jan. 25, 2011

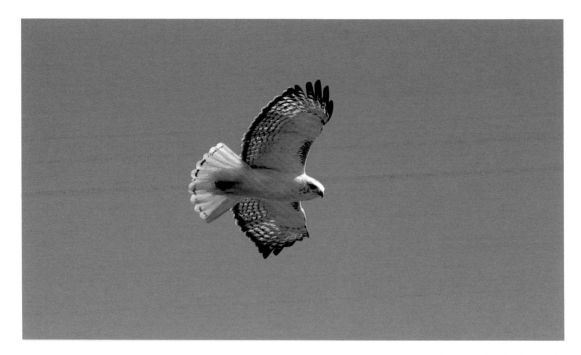

wintering types occur in pairs and are very probably mated since they can frequently be seen sitting within one foot of each other, sometimes both perched closely together at the top of the same pole. They can also be seen soaring and calling together, chasing interlopers from their winter territories together, and, most notably, performing the very distinctive Red-tailed Hawk courtship displays in early spring before departing for their northern breeding areas. Often when one adult is disturbed it will soar up and quickly be joined by another that matches its rare type. None of this is surprising, since Red-tailed Hawks are known to form strong pair bonds and stay mated perhaps most of their lives.

Another easy observation for a regular winter hawk watcher is that hawk numbers fluctuate from year to year and from area to area. The hawks may be quite abundant in some years, but nearly absent in others, over both small and large areas. These fluctuations have been shown to be related to the cyclic ups and downs of the rodent populations they depend on.

It may be that Red-tailed Hawks, like many of their close relatives, have visual skills that enhance their ability to locate concentrations of rodents rather quickly. In particular, predatory birds have the capacity to see ultraviolet light, a component of sunlight that we cannot see. This ability comes in handy for them because rodent urine shows up brightly in ultraviolet light. Thus, a hawk may be able to determine the extent of rodent activity in a certain area as easily as a rabbit hunter reads tracks in the snow.

The plumages of Red-tailed Hawks are extremely variable, and many have distinctive markings, colors, and patterns that make individuals easily recognizable from year to year. If prey densities are adequate, some birds will return to the same small patches of prairie for many consecutive winters.

Noble Co., Feb. 25, 2012

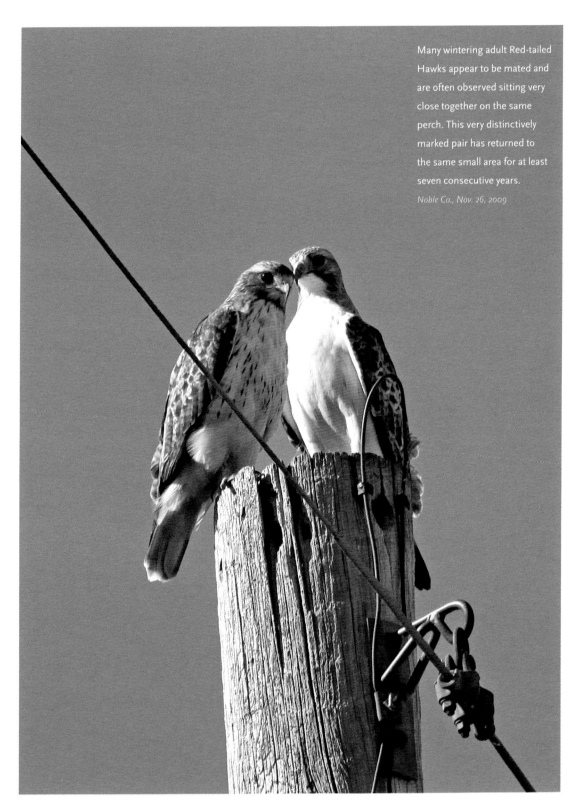

Many wintering adult Red-tailed Hawks appear to be mated and are often observed sitting very close together on the same perch. This very distinctively marked pair has returned to the same small area for at least seven consecutive years.
Noble Co., Nov. 26, 2009

Our wintering Red-tails are also affected by severe Arctic storms. Red-tailed Hawks are quite hardy and can easily endure the average howling north wind or normal amounts of sleet and snow. However, when very harsh Arctic express storms send temperatures plummeting to the single digits or below, or when deep snows are deposited on the plains, many of our wintering Red-tails depart, presumably to more southern latitudes. They must evacuate because the rodents they depend on either die or go dormant. A move of two hundred miles or more to escape the harsh cold is nothing for a Red-tailed Hawk; for them, as for all birds, distance is a minor inconvenience. If the harsh conditions last only a short time then the hawks come drifting back, usually on a warming south wind, and occupy their same favorite perches. Sometimes, however, during severe and prolonged winter storms their prey base is killed off, and areas that had very high densities of hawks before the storm will have almost none once the snow melts and the temperatures warm.

The frequently observed departure and return of wintering Red-tailed Hawks reacting to these Arctic storms begs a couple of obvious questions that

Severe Arctic storms have a depressing effect on the cotton rat populations that Red-tailed Hawks depend on for food in winter. When these storms occur Red-tailed Hawks often temporarily depart their winter territories, presumably to more southern latitudes.

Noble Co., Dec. 26, 2009

When Great Plains winds are harsh, Red-tailed Hawks seek shelter in the woods or the leeward sides of large landscape features, making them much less conspicuous than they are on calm days.

Osage Co., Dec. 12, 2010

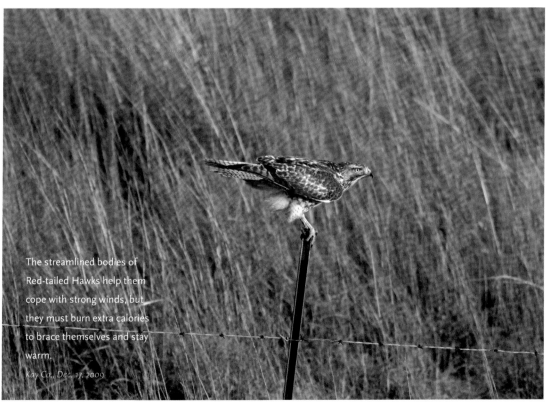

The streamlined bodies of Red-tailed Hawks help them cope with strong winds, but they must burn extra calories to brace themselves and stay warm.

Kay Co., Dec. 17, 2009

could easily be answered with modern satellite telemetry: Have they actually departed, or are they just lying low out of sight? And, do they have other, perhaps several, wintering areas at different latitudes that they frequent? Much remains to be learned by the next generation of Oklahoma Red-tailed Hawk students.

If you plan on going to the prairie to watch hawks in an area where you are used to seeing lots of them, plan on seeing a lot fewer if there are high sustained winds and gusts in excess of fifty miles per hour. On days with high winds Red-tailed Hawks seek perches that are much less exposed. They do not like the brutal Oklahoma winds any better than we do. On those days they may be found on the leeward sides of hills, limestone outcrops, dense woods, pond dams, and overpasses, and often right on the ground. They sometimes sit on power lines, snuggled right up next to the sheltered sides of utility poles. Those that do remain exposed face directly into the wind, their bodies held nearly horizontal to allow their streamlined shape to help reduce the push of moving air against them. Even on very windy days hawks still have to hunt, but they must change tactics. Some, perhaps the more skilled fliers, take advantage of the wind and hover or, with flexed, backswept wings, stay stationary over a fixed point on the ground and study the grass below. When they spot prey they use the fast-moving air to rise up quickly and then slingshot downwind while

By flexing or extending their wings in high winds, Red-tailed Hawks can adjust their lift and establish a nearly fixed, elevated position from which to hunt. Even on windless days, Red-tailed Hawks can hover and accomplish the same thing, but with a greater expenditure of energy.

Noble Co., Nov. 14, 2014

accelerating rapidly, allowing them to chase down and capture fast avian prey that could normally outfly them.

The best days to watch winter hawks on the prairies are days with clear skies and mild winds that follow prolonged periods of inclement, overcast weather. Hawks come out in force on these days and are very active. After rainy spells they are frequently seen with half-spread wings catching the morning sun and drying out a little. These clear days after overcast winter weather not only provide perfect opportunities for watching hawks; they are also great days just to be outdoors, with hawks or without. Also, you don't have to get up early to enjoy good Red-tail watching. Often, the period from midafternoon to sunset is the best time to see them.

Red-tailed Hawks can be observed occupying their favorite hunting perches starting with the earliest morning light. They will often stay out until nearly dark, but they do not spend the night on their exposed hunting perches.

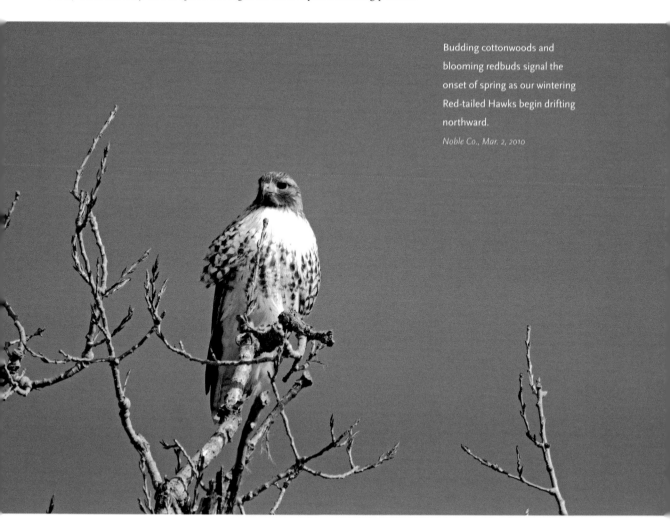

Budding cottonwoods and blooming redbuds signal the onset of spring as our wintering Red-tailed Hawks begin drifting northward.
Noble Co., Mar. 2, 2010

Just before nightfall Red-tails will fly to more sheltered areas to roost. On the prairies of north-central Oklahoma, this usually means retreating to the woods along streams or rivers, where they seek out deciduous trees with large trunks that will shelter them from harsh winds or eastern red cedars whose dense evergreen foliage will also protect them from the elements. In some areas of North America, several might roost together in winter. On occasions when I have stayed in the field late just to try to see where hawks go to roost, they have often, in open country where many eyes could be watching, taken either very direct or sometimes very low-level deceptive routes into the woods well after sunset, sometimes when it is quite dark.

Typically, by early March signs of spring begin to appear across Oklahoma from south to north in the forms of budding elms and cottonwoods, blooming redbuds, and milder days. When this trend begins, our wintering Red-tailed Hawks gradually depart for their nesting territories in the north. On the prairies of north-central Oklahoma the arrival of Turkey Vultures in early spring almost always signals the gradual departure of our wintering Red-tails. Some, however, do stay here on their wintering grounds as late as mid-April.

The Prairie Food Chain

Red-tailed Hawks are not picky when it comes to eating. They are the ultimate generalists of the raptor world. They strive to expend the least amount of energy necessary and to pursue prey that is the easiest to find and catch and that will adequately fill their bellies. They can, however, when pressed by hunger or the necessity of raising young, catch and kill dangerous animals that

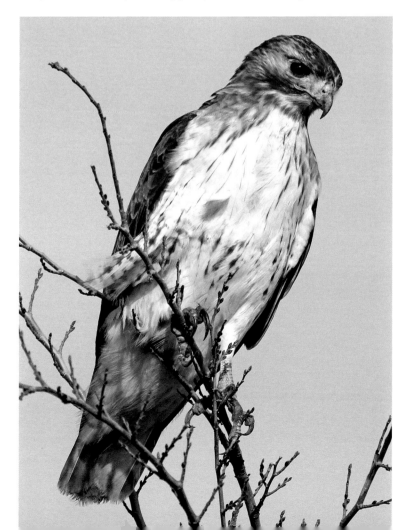

The Red-tailed Hawk is perhaps North America's most adaptable raptor. It is equally at home hunting from a prairie cottonwood, a New York City skyscraper, or a Sonoran Desert saguaro.
Kay Co., Dec. 8, 2011

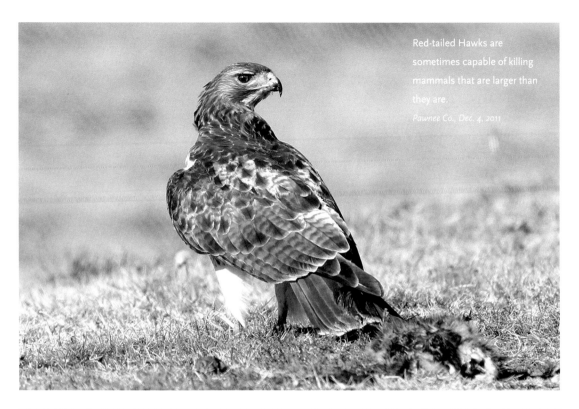

Red-tailed Hawks are sometimes capable of killing mammals that are larger than they are.
Pawnee Co., Dec. 4, 2011

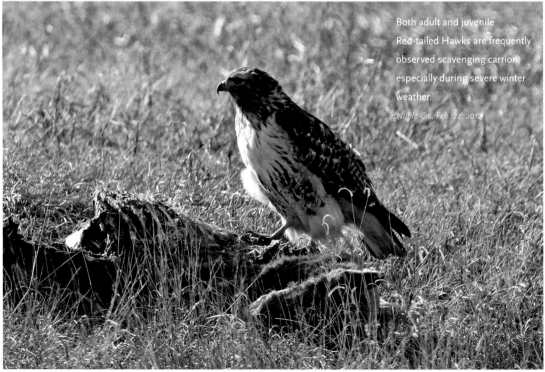

Both adult and juvenile Red-tailed Hawks are frequently observed scavenging carrion, especially during severe winter weather.
Noble Co., Feb. 24, 2012

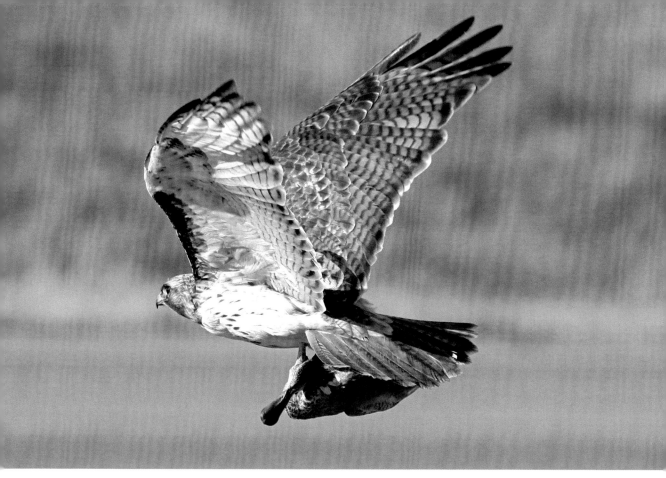

are easily as large as or larger than they are, such as large jackrabbits, young raccoons, and other large birds. But they will also readily eat insects and small vertebrates of all kinds, and they will scavenge if necessary; survival is their highest priority.

Having studied wintering Red-tailed Hawks on the tallgrass prairies of Oklahoma for many years, I have had the opportunity to observe them with prey on numerous occasions. I have witnessed them eating cottontail rabbits, young opossums, numerous fox squirrels, Red-winged Blackbirds, Meadowlarks, Mourning Doves, several pigeons, other small unidentified birds, and snakes both large and small during the warm days of early fall and early spring. I have seen them scavenge all kinds of carrion from highways: skunks, armadillos, opossums, raccoons, house cats, coyotes, white-tailed deer, and occasionally other road-killed hawks and owls. During severe winter weather I have even observed them scavenging fish washed up along lakes. I have seen them vigorously pursue Ring-necked Pheasants and waterfowl. Being near the top of the food chain means they will kill and eat anything they can in order to survive. However, on the tallgrass prairies of Oklahoma in winter, all other food sources pale in comparison to the cotton rats, which the hawks,

A Red-tailed Hawk flushed from a bar ditch near a busy highway flies off with a Northern Shoveler. It is unknown whether the hawk actually killed the duck or found it as carrion.

Noble Co., Jan. 5, 2013

as one of the most efficient rodent hunters on the prairie, pluck in enormous numbers from their grassy homes and rapidly consume. Cotton rats, because of their plumpness, large size, and often somewhat stubby tails, are easily identified while being carried off by hawks. Considering the range of prey that Red-tailed Hawks utilize, including many species that are much more powerful and dangerous than cotton rats, these plump rodents are relatively safe prey and are easily subdued, notwithstanding the occasional non-life-threatening bite on the foot. The feet of many old Red-tailed Hawks do show battle scars, presumably from rodent bites. However, the powerful viselike feet of the Red-tailed Hawk can completely encompass these rodents. Armed with eight very sharp talons, they no doubt snuff the life from these little guys fairly quickly, inflicting great internal hemorrhaging and rapid suffocation by literally squeezing the air from their lungs. In fact, Red-tailed Hawks are probably overkill for cotton rats. Even perky little American Kestrels, falcons the size of a Blue Jay and one of North America's smallest raptors, are sometimes seen on the prairies carrying cotton rats nearly as big as they are. The feet of birds of prey, even the small ones, are amazingly efficient killing instruments; there is nothing else like them in other vertebrates.

Even though in winter Red-tailed Hawks prey most often on cotton rats, food habit studies and winter field observations in Oklahoma have shown that they also eat large numbers of harvest mice, deer mice, and prairie voles. The prairies are also home for a couple of other large rodents that Red-tailed Hawks and other birds of prey probably feed on, though not nearly as

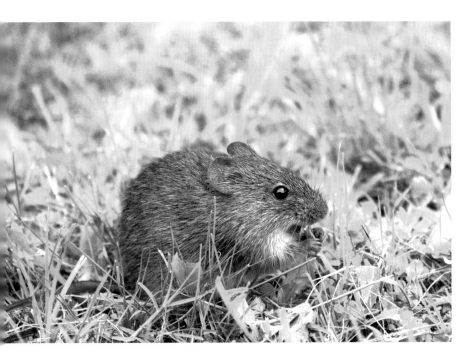

In winter the large, ubiquitous cotton rat is without a doubt the main prey of Red-tailed Hawks on the grasslands of Oklahoma.
Payne Co., May 11, 2009

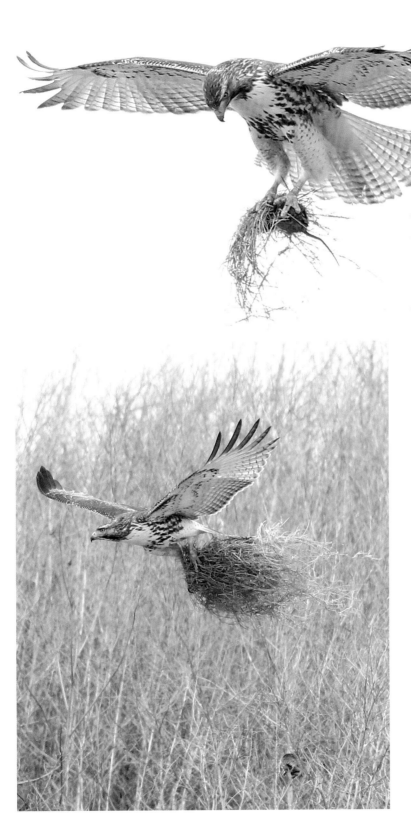

Cotton rats with their large size and rotund bodies are easily identified when being carried by raptors. Their size and abundance make them nearly perfect prey for wintering Red-tailed Hawks on Oklahoma's prairies. As this image shows, Red-tails almost always grasp a large clump of grass along with the unfortunate rodent.

Noble Co., Jan. 1, 2015

Cotton rat air drop! The dense clump of grass being carried off by this young Red-tailed Hawk is perhaps the nest of a cotton rat. It is no doubt a lucky day for this rat, which can be seen in the lower right dropping to the ground and escaping the deadly clutches of its omnipresent winged enemy.

Kay Co., Jan. 10, 2015

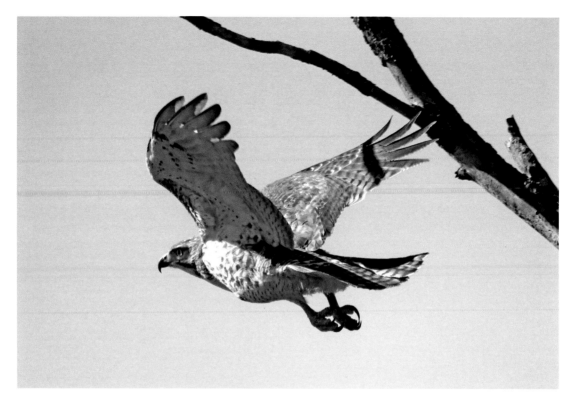

The powerful feet and sharp talons of Red-tailed Hawks quickly inflict internal hemorrhaging while their viselike grip literally squeezes the life from rodents the size of cotton rats; they are easily subdued by medium-sized raptors.

Payne Co., Jan. 31, 2009

frequently as they do on cotton rats. Wood rats, locally known as pack rats, are quite large. Their nests, sometimes two to three feet across, are made of sticks and other collected odds and ends are sometimes seen in trees out on the prairie, but more often they consist of large piles of sticks on the ground in the woods. Wood rats are mostly nocturnal and may not be as exposed to predation by Red-tailed Hawks as they are to owls. Norway rats, another prairie denizen, are common, unwelcome inhabitants of agricultural buildings, especially where grain or feed is stored. They, like wood rats, can wreak havoc on the electrical systems, coolant hoses, and all soft, gnawable parts of unprotected agricultural equipment. I speak from experience when I say that these rodents, with their incessant desire to chew on almost anything, can cause hundreds of dollars of damage to a tractor left out overnight. Once I witnessed an adult Red-tailed Hawk, which frequently hunted near a cattle feeding area, cross the road in front of me at very close range carrying by the head what I am pretty sure was a huge Norway rat, with its long, naked, very limp tail trailing behind it like the tail of a kite in the wind. The size of the rat in relation to the hawk was very impressive, but in typical Red-tailed Hawk fashion the bird quickly disappeared from view into a nearby wooded drainage. Within seconds the curtain was down on the whole exciting scene.

Red-tailed Hawks are often associated with old abandoned farms. Many

of these are overgrown with vegetation, and their collapsing sheds and barns obviously provide lots of habitat for all kinds of small quarry. Red-tailed Hawks often hunt from atop the barns and roofs or from nearby tall trees. Hawks hunting near these old homesteads present a rustic scene reminiscent of bygone days on the prairies. They also hunt from utility poles right in the yards of active rural homes. Obviously, where there is feed for domestic animals there are rodents. Some country dwellers are quite protective of "their hawks," but others, unfortunately, are not.

Once a Red-tail captures a large cotton rat, it can dismember and consume it in a matter of minutes, and the whole critter—tail, feet, head, guts, fur, and all—ends up forming a compact bulge in the hawk's crop that can be seen at a great distance. Like most raptors, hawks cough up the indigestible remains of their prey in the form of a neat, solid, furry pellet, usually within twenty-four hours after devouring the meal. These pellets, which the hawks drop below their high-use hunting perches, are not hard to find and leave telltale evidence of the birds' favorite meals. Don't expect to find rodent bones in them, though, as the digestive acids in hawks' stomachs are very powerful and normally

Decades have passed since the voices of Oklahoma's early European settlers were heard near their homesteads. Now abandoned, these dilapidated old structures have become overgrown and inhabited by numerous small animals, making them perfect hunting grounds for Red-tailed Hawks.

Noble Co., Mar. 16, 2009

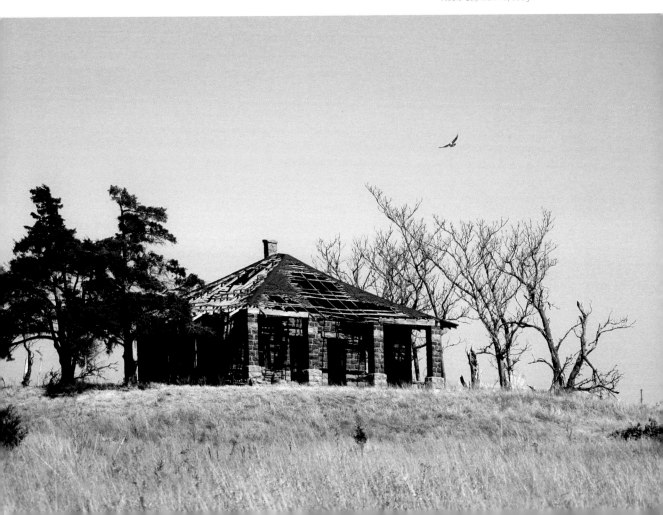

completely dissolve them. Pellets with rodent bones in them are usually owl pellets. The unique fur of the cotton rat, however, is very easy to identify and comprises most of the pellets from Red-tailed Hawks. The official common name for the cotton rat is actually hispid cotton rat. "Hispid" means shaggy or rough and refers to the rats' rather unkempt appearance. The bottom line is that the top three food items for Red-tails in winter in Oklahoma are: rodents, rodents, and rodents.

Understanding a predator's main quarry helps put that predator in perspective. For the wintering Red-tailed Hawks on the tallgrass prairies of Oklahoma, that means learning a little bit about cotton rats. Although they can be very destructive, cotton rats are an important part of the prairie ecosystem and are interesting creatures in their own right. They are one of the most abundant rodents on the southern grasslands. Our Oklahoma cotton rats are pioneers, so to speak. At our latitude they are near the northern limit of their range, which extends south as far as northern South America. In other words, they are mostly warm-weather animals. In the warmer parts of their range cotton rats reproduce all year, but here in the north their reproduction ceases from November until March. During normal years in Oklahoma cotton rat populations are at their highest in November and then steadily decline, until the rats start to reproduce again in March. The Red-tailed Hawks that come here for the winter are lucky in that their arrival coincides with what is normally the highest annual peak in cotton rat populations.

The rotund cotton rats seem made to order for medium-sized raptors. They are quite large and weigh from 2.5 to 7.5 ounces; so at the top end of the scale that's nearly a half-pound rat! However, most weigh only about 3.5 ounces. Unlike many prairie rodents, they are quite active during the day, which makes them vulnerable to hawk predation, but they also get no reprieve at night, when owls and other nocturnal predators pursue them. The only hope their species has of surviving the constant whittling away of their numbers by predators is to reproduce like crazy, and this they do with great efficiency. They become sexually mature in as few as forty days. The females enter estrus every seven to nine days, and immediately after giving birth. They have a short gestation period of only twenty-seven days and have litters as large as twelve, but five to seven is normal. They are weaned at five days and their average life span in the wild is only about six months. Reproduction that is always at the edge of what's possible does have its drawbacks, one of which is that the population is subject to enormous swings in numbers, with extreme highs often followed by crashes. That's exactly what happens to cotton rats, especially the populations here at the northern extent of their range.

Irruptions are impressive to witness. One well-documented and widespread irruption occurred in Oklahoma in 1958. I was eleven years old

at that time, and one day while rabbit hunting with my older brother John on the tallgrass prairie near Bluejacket, Oklahoma, we witnessed that irruption. I remember there was wet snow on the ground, and the minute we got out of the car and began to load our shotguns we started seeing rodents. At the time, I didn't really know what they were, but it was hard to miss the large rats that were essentially everywhere. It was not until years later that I learned they were cotton rats. It is no exaggeration to say that during that winter you could barely take a step without flushing a cotton rat. They were even in cities. But the population eventually crashed, and then they were nowhere to be found. Essentially a southern species, cotton rats are very sensitive to prolonged Arctic weather and deep snows, which can cause die-offs over large areas. After these population crashes, cotton rats may remain locally extinct over large areas for several years. During normal years cotton rat densities are around 45 per acre but during irruptions there can be as many as 145 per acre.

It may not be a mere coincidence that state legislation to protect most of Oklahoma's hawks and owls was passed in 1959, just one year after the cotton rat irruption of 1958. Two prominent Oklahoma ornithologists from that era, George Sutton from the University of Oklahoma and John S. Tomer of Tulsa, both informed me that the irruption caused great concern among Oklahomans. So they and other conservationists took the opportunity to write articles for some major Oklahoma newspapers touting how beneficial birds of prey were and how rodents, especially cotton rats, were a major part of their diet. The articles were accompanied by paintings of raptors by Sutton and Wallace Hughes, an artist from the Tulsa Zoo who later became staff artist for the Oklahoma Department of Wildlife Conservation.

Cotton rats are omnivorous. They feed on vegetation, insects, seeds, and small animals of all kinds. They destroy both the eggs and chicks of Northern Bobwhites and other ground-nesting birds. They can be extremely destructive to crops. Their favorite habitat is tall grasses, especially unmowed areas near roadsides and railroad tracks. They maintain numerous runways beneath the grass, which interconnect nests and feeding areas. When Red-tailed Hawks hunt on roadsides they watch humans pass by on the roads while at the same time catching brief glimpses of cotton rats traveling their grassy byways. No doubt it pays to sit beside busy rat highways if you are a Red-tailed Hawk.

Roadsides and railroad track rights-of-way, with their thick, often unmowed grass and evenly spaced perches, make perfect areas for Red-tailed Hawks to exploit rodents, and such places are where Oklahomans most frequently see these birds. Roadsides are prime real estate for Red-tails. Rural roads with low traffic are where Red-tailed Hawks put on a great show in Oklahoma in winter, and it is also safe to watch them along these back roads. But spectacular viewing also occurs along some of our major turnpikes and

Grassy roadsides with evenly spaced posts and utility poles provide excellent habitat for Red-tailed Hawks to hunt cotton rats and other small quarry. Oklahoma's rust-colored back roads are good places to safely watch hawks.
Garfield Co., Dec. 12, 2010

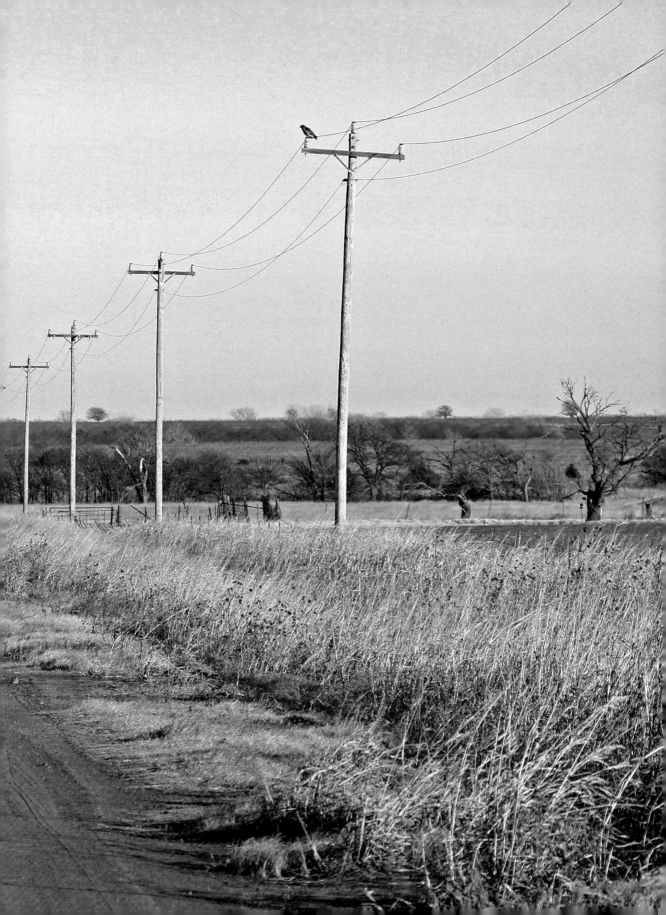

interstate highways. The Will Rogers Turnpike from Tulsa to Joplin, Missouri, is jam-packed with Red-tailed Hawks during some winters, as are parts of the Muskogee Turnpike. Along these very busy thoroughfares Red-tails are probably less disturbed than they are along some rural roads. For one thing, the wider rights-of-way mean they are actually farther away from the traffic than they are on the side roads, and also the cars are traveling at high speeds and don't usually stop. Red-tailed Hawks hunting adjacent to extremely busy interstate highways often tempt fate by darting from one side of the highway to the other, perching on road signs right next to the highways; many get hit. Counting them along highways can make traveling fun, but for safety's sake never stop on these busy roads to look at hawks; it is DANGEROUS.

It is common to see Red-tailed Hawks intently studying the grass directly below their elevated perches, sometimes with their heads cocked straight down. Other times they stare intently and make direct eye contact with people in close-passing vehicles. On the back roads where it is safe to slow down and look at them, you can tell they are occasionally conflicted between watching you, the threatening human, and scanning for a potential meal. Other times they can be completely distracted by neighboring hawks intruding into their areas and they will nearly ignore a human, even one that is very close. These, however, are about the only situations in which healthy Red-tailed Hawks might allow humans to approach closer than normal. Most of the time wintering hawks out on the prairies are extremely wary of humans and will flush from their perches at great distances when a vehicle approaches. Some will take flight nearly a half mile away. In fact, it seems that many, especially those whose favorite hunting perches are near high-traffic rural roads, spend a good part of their day taking flight at the approach of a vehicle, arcing out away from the road and then returning to the same perch to continue hunting when the vehicle has safely passed. They do this over and over again throughout the day, but apparently the rat hunting is so good in some of these areas that it is worth the extra energy expenditure.

Over the years, while driving literally thousands of miles and encountering many thousands of hawks, it has become frustratingly apparent to me, since I always wish to get a close look at them, that these intelligent birds will do almost anything to keep from being in the direct line of sight of a driver of a close-passing vehicle. Instead, when disturbed they will fly to the passenger side of a vehicle with a lone driver. If they can't cross over they will certainly fly directly away with great speed. Of course, this quickly puts them in a position in which it is more difficult for them to be photographed (or shot). They will also quite skillfully put things between you and them, such as woods, signs, and hills; their evasive behaviors are quite uncanny. This aspect of Red-tailed Hawk behavior has, on occasion, made these birds that I love so dearly

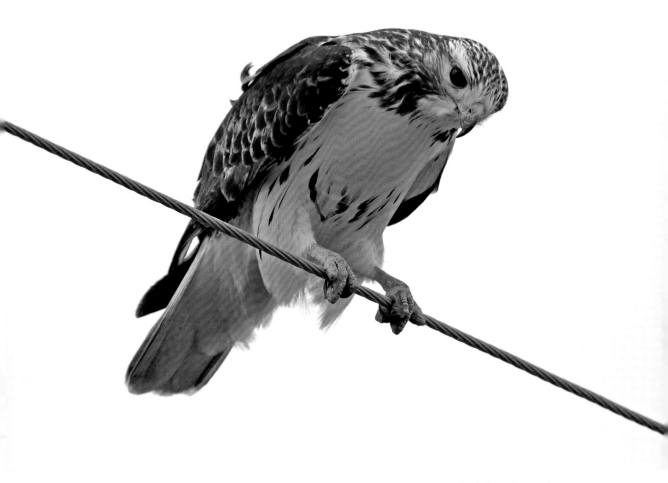

Red-tailed Hawks intently studying the grass below their elevated perches are a common sight in Oklahoma during winter.
Grant Co., Dec. 18, 2010

recipients of some of my more colorful and least used expletives; luckily, I am almost always by myself.

Because Red-tailed Hawks love hunting near roadsides, Oklahomans frequently see them attacking cotton rats. Compared to a lot of raptor prey pursuits, these rat attacks are kind of unexciting unless you are a hawk enthusiast. Basically, the hawk sights the prey from a lofty perch and then takes off in an almost straight line, mostly flapping at first, then gliding near the end of the trajectory to the prey and often crashing into the grass after it. Sometimes, as their wing and tail feathers collide with the tall, stiff vegetation, the crash is loud enough to be heard at quite a distance on a calm day. Other times they jump off a utility pole and dive nearly straight down to the base of it to catch a rat. Another variation in hunting technique is the close-to-the-action approach, in which the hawk will hunt from low perches such as fence

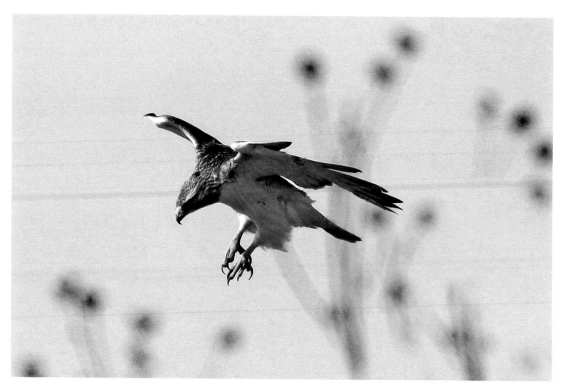

A cotton rat's worst nightmare. This adult Red-tailed Hawk has just taken flight from its hunting perch and is closing fast on a possible meal.

Kay Co., Dec. 5, 2009

posts, small shrubs, or the ground. In these situations the flight, or jump, from perch to rat may be only two or three feet. Only once have I witnessed a Red-tailed Hawk abruptly break out of a soaring pattern and drop to the ground in a falcon-like dive and catch a rodent.

Once the Red-tails capture their prey, they either eat the animal on the ground or fly back to a high perch with it and consume it there. Other Red-tails often see this and will fly in to investigate and perhaps steal a meal. It's not uncommon to see five or six hawks near a kill.

Very intricate cotton rat runways are sometimes exposed after intense prairie fires, but the rat highways that run parallel to the roadsides sometimes become evident from the behavior of the hawks. For example, in Noble County I once watched a Red-tailed Hawk perched on a utility line, head cocked down, studying the grassy roadside in typical Red-tail fashion, when suddenly it lost interest. But rather than flying off or staying there it flew down the line about twenty feet and immediately took up watching the grass again. It gazed for several minutes and then, as before, flew down the line a few more feet and began intently studying the grass below. Within a minute or two at this third location it jumped off the line and with a very audible crash plunged into a patch of tall dried sunflowers and emerged with a cotton rat. It then flew to a pole and very quickly consumed the unlucky creature. Apparently it had anticipated the

Prairie Food Fight

This Red-tailed Hawk has just captured a Meadowlark, but as this sequence clearly shows, catching prey means you sometimes have to fight to keep it. The supersharp eyes of other hawks are always watching on this open landscape.

Kay Co., Dec. 15, 2011

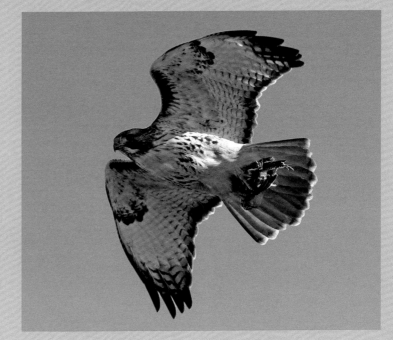

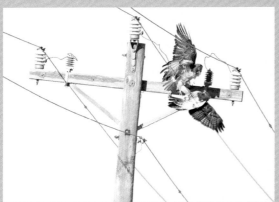

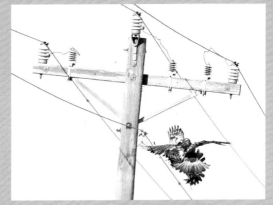

Feathers start to fly when the hawk with the Meadowlark attempts to land with its prey on a nearby pole. It is quickly attacked by another hawk, which forces it to hang on to its prey with one foot and defend itself from the potentially wounding strikes of its competitor with the other; entangled, they plummet to the ground.

Kay Co., Dec. 15, 2011

Except for a few messed up feathers, the hawk that originally captured the Meadowlark retains its prey and flies off to another location to consume it.

Kay Co., Dec. 15, 2011

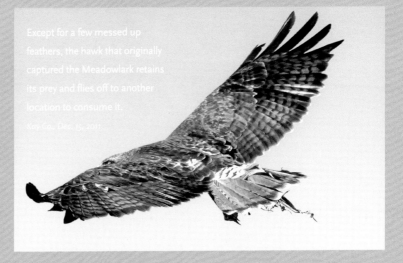

The Prairie Food Chain

An adult Red-tailed Hawk closes fast on a hen Ring-necked Pheasant. This story, however, does not end with the demise of the pheasant but rather, as often happens, with a hungry hawk returning to its perch.
Garfield Co., Nov. 14, 2010

rat's movement down its runway and had moved ahead for an ambush.

Not all Red-tailed Hawk hunts are low on action, though; some are very exciting. Once I saw a Ringed-necked Pheasant flush right beneath an adult Red-tailed Hawk sitting on a pole as my truck approached them along a rural road. The hawk immediately pursued the hen pheasant, and with its altitude advantage it closed fast; the pheasant was in a race for its life. Within about three feet from the pheasant and about a hundred yards from their starting position a Northern Harrier, another rat-eating prairie hawk, came out of nowhere and dove at the

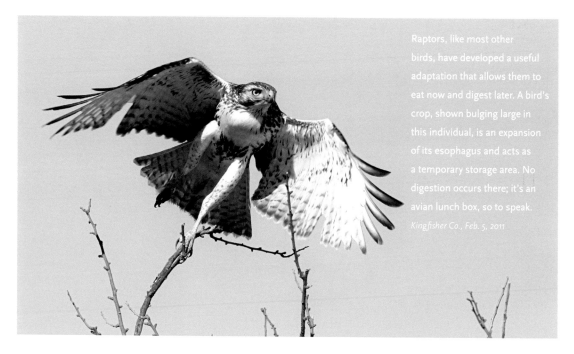

Raptors, like most other birds, have developed a useful adaptation that allows them to eat now and digest later. A bird's crop, shown bulging large in this individual, is an expansion of its esophagus and acts as a temporary storage area. No digestion occurs there; it's an avian lunch box, so to speak.
Kingfisher Co., Feb. 5, 2011

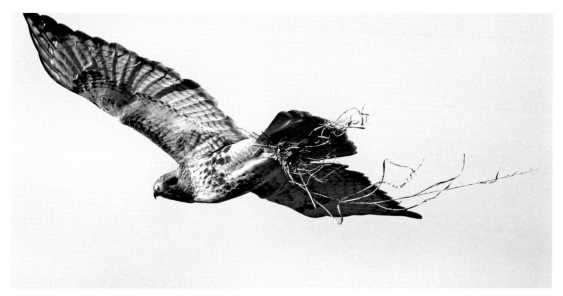

Red-tailed Hawks are frequently observed flying back to their hunting perches with long stems of prairie grass trailing from their talons.
Noble Co., Nov. 25, 2009

Red-tail. In order to defend itself from the smaller but lethally armed attacker, the Red-tailed Hawk rolled over and presented its talons to the harrier. This gave the pheasant the split second it needed to escape to cover.

Red-tailed Hawks and Northern Harriers don't seem to like each other too much. Several times I have observed Red-tails going straight to a spot in the grass where a harrier went down to catch prey and flushing the surprised harrier, most likely hoping to steal its prey. Northern Harriers, however, are lighter on the wing than the heavier Red-tails and can rise above them quickly. In raptor aerial combat the bird with the higher altitude has a decided advantage, so most of the time the Northern Harriers are usually the ones doing the harassing.

Given that in captivity Red-tailed Hawks require about five ounces of food per day and that a single large cotton rat can supply that much, one rat per day might be enough for basic survival. Wild hawks are much more active than captive ones, though, and must burn calories just to keep warm. They must also use muscle strength to brace themselves against the incessant Great Plains winds, so they might need more calories per day. It is hard to determine how many cotton rats a hawk can catch per day, but it is not uncommon to see Red-tails with bulging crops pursuing cotton rats, so obviously there is always room for one more.

It's also common to see Red-tails flying back to their high perch with long stems of prairie grass trailing from their clutched talons. This is a puzzling behavior because there is often nothing but grass in their feet, and it might look like prey and therefore attract other raptors. Perhaps they get so excited during a near miss that it takes them a while to calm down and realize that the meal they were hoping for has actually escaped. Or perhaps they have just

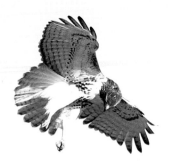

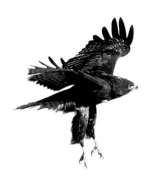

On the prairies of Oklahoma in winter, Red-tailed Hawks are often densely packed in good hunting areas where prey is abundant, so interactions between them are frequent.

Noble Co., Nov. 29, 2014

finished a meal and there is some kind of residual excitement. No one really knows. When they are successful they almost always seize a large clump of grass along with the hapless rodent.

Red-tailed Hawks are often packed close together in prime hunting areas, so interactions between them are frequent. Red-tails are capable of spectacular aerobatic flights, but these are usually reserved for courtship and territorial displays during the breeding season. However, even in winter one can observe some impressive flying when hawks interact, usually in disputes over captured prey or hunting space. These hawks, like most high-spirited birds of prey, seem to enjoy impressing their peers with daredevil rolls, chases, and dives, but in reality many of these interactions are deadly serious and driven by a single strict imperative: survival. It is very obvious that when Red-tailed Hawks are closely spaced, territorial borders are in a fragile equilibrium; when one hawk violates another's space it sets off a series of interactions that may last an hour or so before all parties settle back down.

Before we leave the topic of Red-tailed Hawk food habits, it is very important to mention, just to highlight how beneficial these birds are, that during the warmer months of the year snakes of many species form a very important part of the hawk's diet. In fact, snakes are just as important to Red-tails in the warmer months as cotton rats are to them in the winter. This is notable because so many snakes are nest predators of game birds and songbirds. Red-tailed Hawks are capable of killing rather large serpents, even some powerful and venomous species like rattlesnakes. Even though a striking rattlesnake seems quick, it is slow compared to the lightning-fast reflexes of birds of prey. Occasionally, however, large serpents do kill hawks.

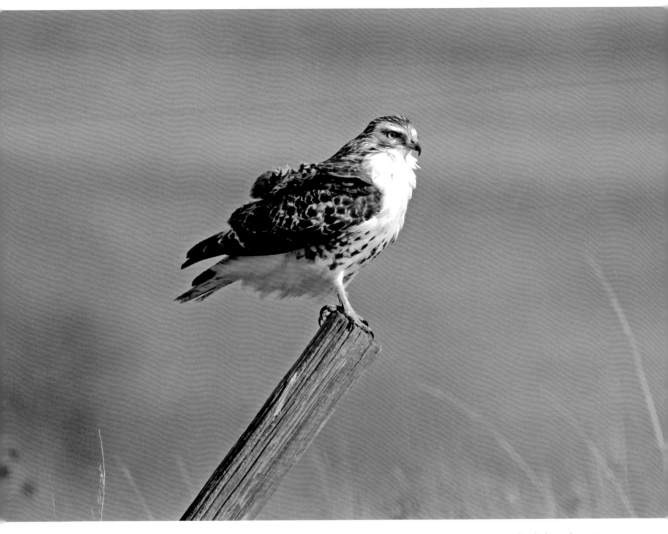

Young Red-tailed Hawks going into their first winter confront extreme survival challenges; most will not live to see the following spring. Humans, severe weather, and other hawks are dangerous threats, but starvation is perhaps their deadliest nemesis.
Grant Co., Dec. 19, 2010

Growing Up a Hawk

Some of my most exciting experiences in the outdoors were hunting adventures in Ottawa County with my brother John. I was steeped in the hunting culture and loved every second of it. But even from my very youngest years I have never understood the outright disdain a minority of hunters hold for predators. You would think they would feel just the opposite since predators, like themselves, must hunt and outsmart fast and cunning quarry that wants to avoid getting captured at any cost. Wild predators must live by their wits, with much more at stake than a trophy for the wall. Their efforts are admirable, and death can come from above or below at any time, or through a miserable and painful withering away by starvation. They are on their own with no enablers to help them. I am sure if they could choose they might pick an easier lifestyle; they just can't eat broccoli. They were born to kill, and killing, as with human hunters, is a skill that takes time to perfect.

Survival is challenging for both adult and juvenile Red-tailed Hawks at all times of the year, but it is especially so for young birds that fledged from their nest the previous spring and are facing their first winter. Young Red-tailed Hawks go through a harsh hazing ritual before they can become adults and acquire a mate and territory of their own, which is, other than their next meal, their primary goal in life. Typically, their first winter is a survival bottleneck that will eliminate many of them, but no one really knows, on average, what percentage will perish. Nature is neither kind nor cruel. It is completely indifferent, and the result of that indifference can be seen in many of the Red-tailed Hawks one encounters on the prairies of Oklahoma in winter.

The deck is definitely stacked against young Red-tailed Hawks, in part because they are almost always at the very bottom of the Red-tailed Hawk social order. Their world is much more three dimensional than ours because they can fly above the landscape, but whether they are high in the air or perched near the ground they often face withering attacks by both resident adult hawks and adults than come here for the winter. They are therefore

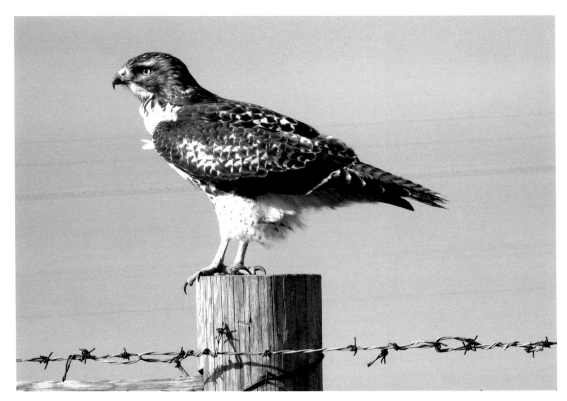

In winter the tallgrass prairies of Oklahoma are jam-packed with aggressive adult Red-tailed Hawks, so juveniles like this one typically end up occupying marginal winter habitat.
Noble Co., Oct. 30, 2009

typically forced to live in marginal areas; in other words, they get the leftovers. Juveniles soar less than adults, and when they do they are often attacked.

Just to show you how intense these attacks against juveniles can be, the following account leaves little doubt about the rough neighborhood these first-year hawks live in. The late Craig Lowe, a biologist who studied wintering Red-tailed Hawks near Oklahoma City, followed what he thought was a young male Red-tailed Hawk for a distance of twelve miles after an adult chased it from its perch. At least nine more adults chased and escorted this young bird along its route until it finally gained a reprieve by perching atop a power pole in a newly constructed residential area in Oklahoma City. I find this very easy to believe, as many of these chases take place high in the air and the young hawks frequently have to flip over and grapple with the aggressor, so the flights paths are rather slow and easy to follow across the landscape. Adult hawks often hit young hawks with direct contact or force them out of the air, sometimes killing them. This has been observed in many other areas of the United States, and it may explain why you sometimes see pockets of several juveniles occupying very small areas of only an acre or two. Perhaps these are the only safe areas in a landscape crowded with aggressive adults.

Sometimes, adult Red-tails don't even have to attack juveniles to cause them to fly away. All it takes is for an adult to give them the proverbial "look." In Red-tail lingo this usually means leaning forward with a direct, glaring stare. The adults erect their nape and breast feathers, which makes them appear larger, and watch every move the youngsters make. In some situations, however, usually when the weather is bad and the adults have full crops, they allow juveniles to perch closer without attacking them.

Most adult Red-tails have nearly perfect plumage in winter because they have just completed their annual molt and growth of new feathers. Strong, durable feathers are a big survival advantage. In contrast, the young-of-the-year Red-tailed Hawks have worn their feathers since fledging from the nest early in the spring, so by the dead of winter many feathers show breakage, possibly from encounters with adults, crashes into vegetation, or natural breakdown from sunlight. Some hawks show feathers that are so severely worn and broken, one wonders how the birds can possibly survive—and many don't. However, some young-of-the-year Red-tails are nearly perfect and amazingly beautiful. During many winters young Red-tailed Hawks, that is, those that fledged from the nest the preceding spring, are almost absent on the tallgrass prairies of north-central Oklahoma. I have often wondered whether this is because of poor productivity of young hawks on their northern nesting territories during certain years or because these grasslands are such high-value Red-tailed Hawk turf that the more aggressive and seasoned adults nearly completely drive the young away. Whatever the reason, the absence of young birds some years is very striking. The behavior of young Red-tails is markedly different from that of adults. Often, young Red-tailed Hawks will let humans approach much closer than adults will, especially if they are very intent on watching prey in the grass.

Anyone who has kept birds of prey in captivity and really gets to know how they behave learns to recognize the bright-eyed, attentive look of a healthy hawk as opposed to the listless, half-open eyes of one that is sick. Lots of young Red-tails have that sleepy look in broad daylight, indicating they are having a hard time. Starvation is perhaps the deadliest threat to a young hawk's survival during its first winter.

Starvation, it seems, motivates some young hawks to do things that they would normally not do such as feed closely together on the same food source. I once watched three juvenile Red-tailed-Hawks feeding together, rather peaceably, on the remains of a cottontail rabbit near a rural roadside. On another occasion, a brownish moving mass near the edge of a soybean field caught my eye, and since I was rapidly approaching in my truck I was quite close to it before I stopped, and then I could see four juvenile Red-tails feeding on a young opossum. I do not know if they had killed the opossum or

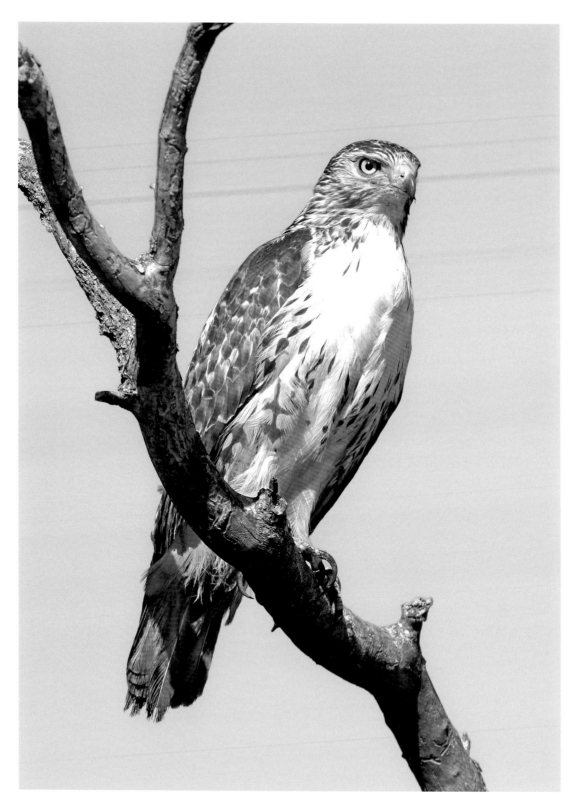

just found it dead near the road. They flushed when I got too close but came back to the opossum when I drove away. I did not want to disturb them, so I left and returned later and investigated the remains. Even the fleshy tail of the opossum had been picked clean.

Extreme hunger or imminent starvation might also explain the unexpected behavior of young hawks chasing adults hoping to get food. When you think about it, not many days have passed in the lives of these young hawks since they were leading the good life and getting food from their parents. Their hunger calls in spring are well known by those familiar with Red-tailed Hawks. I have never heard their begging calls in winter, but I have frequently seen them chase adults that have captured cotton rats. Some of these chases last a long time and can cover quite a bit of ground. The juveniles come right in under the rat-bearing adults and try to snatch their prey, but the more skilled adults are quite adroit at keeping it. I have never actually seen a young hawk be successful at stealing an adult's rat. This behavior seems contrary to the very aggressive behavior adults usually exhibit against juvenile Red-tailed Hawks in winter. But it definitely occurs more often than you would expect. Possibly, the two hawks are related and the young have traveled along with their parents to their wintering grounds.

Even though adult Red-tailed Hawks are hardwired to aggressively chase off interlopers, sometimes, when a superabundance of densely concentrated, easy-to-catch prey is present, territoriality seems to evaporate into thin air. Red-tailed Hawks are often observed hunting Red-winged Blackbirds when the blackbirds forage in huge flocks near agricultural fields, or near the blackbirds' large communal night roosts. In these and probably other situations, Red-tailed Hawks become very tolerant of other Red-tails, and sometimes many can be observed occupying a very small area. For example, in December 2012 in Garfield County, I noticed approximately twenty-five to thirty Red-tailed Hawks gathered in a partially wooded forty-acre private hunting preserve. At first I was worried that they were preying on game birds, but after a few minutes of observation it became quite obvious that they were catching Red-winged Blackbirds that were feeding on sorghum that was left for the quail and pheasants. At one point I could count at least ten adult Red-tailed Hawks in a single tree, loafing with full crops and perching peaceably very close to each other. This event lasted for a couple of days, but eventually the blackbirds moved out and the Red-tailed Hawks disappeared.

Both young and adults are frequently seen scavenging carrion from highways. Once, near Edmond, Oklahoma, an immature Red-tailed Hawk was repeatedly observed scavenging road kills near Interstate 35, but rather than fly from approaching vehicles it would run off the highway to seek shelter in the grass. It was later captured and taken to a wildlife rehabilitator.

(Opposite) Young Red-tailed Hawks that arrive in Oklahoma for winter have the same set of feathers they left the nest with in spring. Consequently, many have heavily damaged plumage by late winter. This young hawk shows damaged tail feathers and feet sodden with blood from its last meal.
Garfield Co., Dec. 11, 2012

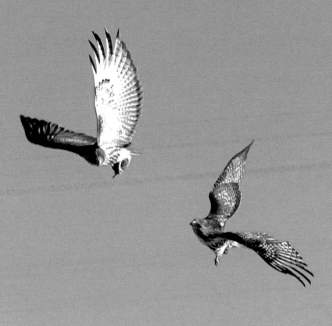

A young Red-tailed Hawk attempting to steal a cotton rat from an adult.
Noble Co., Dec. 15, 2011

The poor hawk had two broken wings that had healed but were too deformed and crooked for it to fly. It had survived, apparently for several weeks, by scavenging. You have to admire any animal that clings to life so tenaciously.

One juvenile bird I encountered in Noble County one winter was an amazing survivor in spite of its severe handicap. It had lost nearly all of its tail feathers and had a conspicuously broken leg that dangled below it when it flew. The first time I saw this bird I thought it had little chance of survival, but to my surprise I observed it repeatedly over a two-month period that winter. The last time I photographed it the discolored, broken foot looked like it might eventually rot away and fall off. It is not uncommon to see foot deformities, injuries, and diseases in both young and adult Red-tails. Bryan Bedrosian, a good friend who studied wintering Red-tails in Arkansas, found that of the eighty-six hawks he trapped, six had foot injuries. When your feet are your main tools for handling biting prey it's no surprise that they get a few battle scars over the years.

Anyone who has hunted birds knows what feathers look like after being hit by shotgun pellets. The large wing and tail feathers are sometimes sheared off in a straight line along the path of the projectile, and individual feathers show ragged, broken edges. Some Red-tails show signs of possible near-death experiences with shotguns and rifles. This is not the least bit surprising. A lot of bad behavior takes place on remote back roads, proof of which is quite

The highly territorial Red-tailed Hawk can sometimes tolerate being crowded in with others when there is abundant, easy-to-catch prey. There are ten Red-tailed Hawks in this single tree; a very unusual sight.

Garfield Co., Dec. 12, 2012

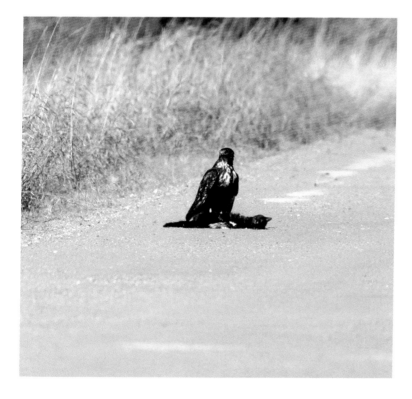

Red-tailed Hawks are frequently attracted to carrion along highways, especially in winter.

Noble Co., Feb. 21, 2012

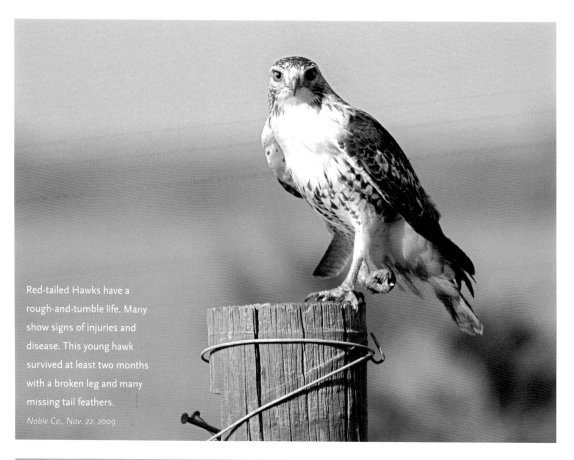

Red-tailed Hawks have a rough-and-tumble life. Many show signs of injuries and disease. This young hawk survived at least two months with a broken leg and many missing tail feathers.
Noble Co., Nov. 22, 2009

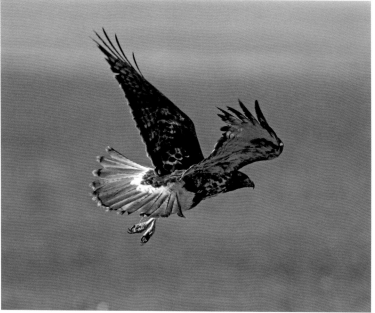

Foot deformities, injuries, and diseases are not uncommon, as shown in this image of an adult with a broken foot.
Noble Co., Dec. 4, 2011

easily seen in the unbelievably high percentage of road signs that are riddled with bullet holes or blasted to pieces with shotgun pellets; some irresponsible people will shoot at anything. Even my own rural mailbox has fallen victim to the twelve-gauge. There is little doubt that the last thing many hawks see is a gun barrel protruding from a pickup window.

Both adult and young Red-tailed Hawks face an even more insidious threat nearly every day due to their love of handy perches provided by utility poles. Some of these poles are so cluttered with wires and insulators that the hawks can barely find room to sit. It is not uncommon to find electrocuted hawks, and I am sure you could find many if you took the time to look for them. Often their corpses dangle by clutched feet to the line that killed them, or they are literally blown into burned pieces by the powerful electric arc. At least it is probably an instant death for these noble hunters.

Sometimes, even devices with far lower voltage than that of power lines can apparently cause problems for Red-tailed Hawks. One of my more unusual encounters with these birds occurred in western Noble County one winter

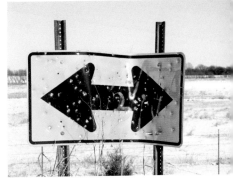

With Oklahoma game wardens spread thin and many miles of back roads, it's little wonder that bad behavior occurs there, as is evident from the impressive number of signs that are riddled with buckshot and bullet holes. An unknown but no doubt large number of Red-tailed Hawks are illegally killed each year.

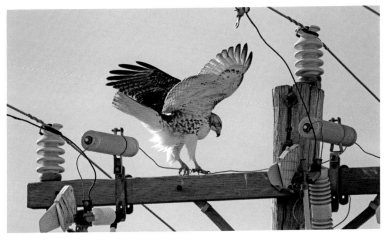

The Red-tailed Hawks' love of utility poles has a definite downside; many die instantly in a flashing arc.
(Above) Grant Co., Dec. 2, 2010
(Below) Grant Co., Dec. 26, 2010

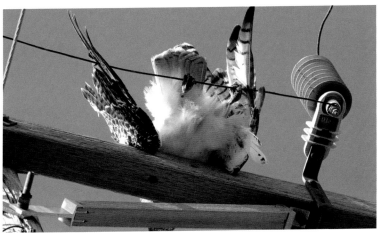

Growing Up a Hawk

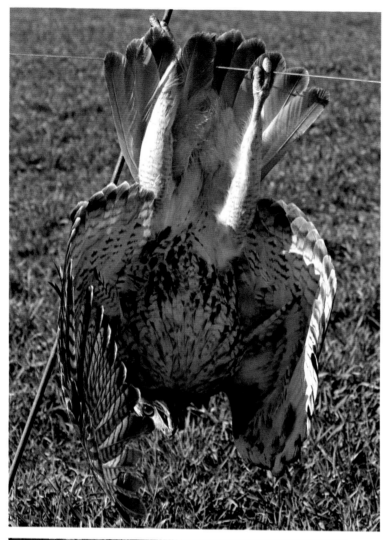

Grounded out, this unlucky hawk hangs paralyzed from an electric fence. Even when it was removed from the fence it remained paralyzed for a short period but soon made a full recovery.

Noble Co., Jan. 12, 2012

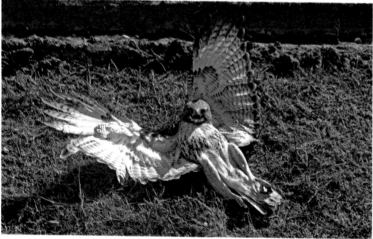

when I came upon an adult Red-tail completely immobilized and dangling from the wire of an electric fence. Assuming the bird was dead, I got out of my truck and began to take some pictures. At that point I realized that the hawk's bright eyes were open and it was still very much alive but nevertheless paralyzed. The bird had obviously made contact between the upright length of steel reinforcing rod and the hot wire and had bypassed the insulator. Knowing that dry feathers are poor conductors, I grabbed the large primary feathers of both wings and pulled the hawk from the wire with surprisingly little effort. However, even after being freed from the wire the hawk was still completely paralyzed, unable to blink or flex any of its joints. I figured the poor bird had sustained massive damage and would need to be euthanized, so I loosely wrapped it in a jacket with the intention of taking it to the veterinary college in Stillwater. I can't imagine what might have gone through this bird's mind as it hung upside down from that fence for who knows how long. When I got back home I unwrapped the bird, and to my surprise it had completely recovered. It was in very good condition, had a strong grip, and could flap vigorously, so I released it, whereupon it flew from my yard and was apparently no worse off for the whole unpleasant ordeal. This hawk was lucky. Seldom when Red-tailed Hawks have close encounters with humans does the story have a happy ending.

Red-tailed Hawks have many threats to their lives, and not all are from humans. When they are on the ground they are very vulnerable to large, powerful mammalian predators such as coyotes and bobcats. Even the air is at times unsafe. Wintering Golden Eagles have nearly vanished from the tallgrass prairies of Oklahoma, but there are a few left, and they are a serious threat to all other birds in the sky—other big raptors included. Large falcons such as peregrine falcons and gyrfalcons can also kill Red-tails. It is very common these days to see Bald Eagles out on the prairies, at great distances from the rivers and reservoirs where we are more accustomed to seeing them. Twice I have witnessed Bald Eagles making vigorous attempts to capture Red-tailed Hawks. One of these attempts was very exciting. I was in eastern Kay County near the Arkansas River, where wintering Bald Eagles are numerous. As I sat in my truck checking the settings on my camera I caught a glimpse of a very large raptor angling across my field of view and within perhaps seventy-five yards of me. It was an immature Bald Eagle, flying fast directly toward the grassy edge of a winter wheat field that bordered a small wooded drainage. I watched it through my telephoto lens as it neared the grass, when suddenly an adult Red-tailed Hawk flushed and flew for its life to the drainage, the eagle within about ten feet of it and closing fast. To my surprise the huge eagle pursued it right into the woods and chased it from tree to tree until the hawk was able to find cover thick enough to protect it. The eagle, apparently realizing it could

Red-tailed Hawks are not top guns in the wild skies over the grasslands. Eagles, both Bald and Golden, winter here and dominate the raptor airspace. In this image an adult Red-tailed Hawk generates maximum thrust to escape an attacking Bald Eagle.
Noble Co., Dec. 10, 2009

not catch the hawk, flew out of the woods and circled up to about two hundred feet over the small drainage. There it hung nearly stationary in the wind and dominated the airspace below it. Within a few minutes the hawk made an attempt to escape, when with lightning speed and a great altitude advantage the eagle dropped like a bullet toward the hawk, which had no choice but to once again retreat to the protection of the woods. The hawk attempted one more escape after that and then never left the protection of the woods the rest of the time I watched. Bald eagles are notorious bullies and are often seen chasing other birds to make them release their captured prey, but this was not one of those incidents. This eagle definitely wanted to eat that Red-tail. Now, I love Bald Eagles and I love Red-tailed Hawks—both are magnificent predators—but I will have to admit that on that day I did not know which one to cheer for.

Red-tailed Hawks are beautiful, fascinating birds that lead challenging lives. You would think they would gain our widespread admiration. But unfortunately, here in Oklahoma they are still heavily persecuted. Once a landowner quite boldly told me to "shoot all of the damn things you want." This is a very common attitude in rural Oklahoma. It has been my experience over the years that no amount of talk can change these well-entrenched, ignorant views. Therefore, the education of young people is the key to change.

No Arrow Can Reach Him

Soaring is where Red-tailed Hawks and most other raptors come into their element and seem to defy the laws of physics. Many an envious human has watched with shaded brow as a soaring hawk is reduced to a tiny speck in the sky and wondered what it would be like to see the earth from that bird's high-ceiling perspective. The "lazy circles" scribed against a sapphire-blue winter sky and made famous in the words of our state song are a common sight on the Oklahoma landscape.

When it comes to soaring, hawks are good at getting something for nothing and are able to extract the energy from warm air with great efficiency.

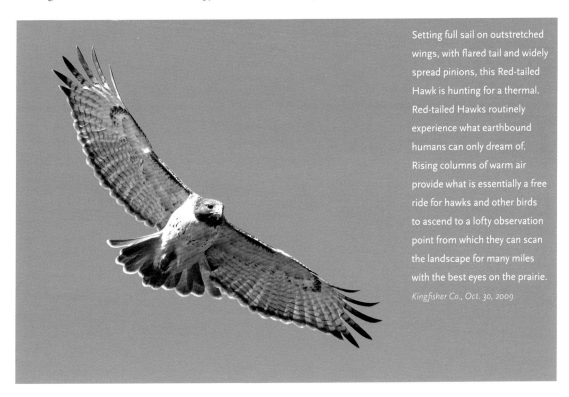

Setting full sail on outstretched wings, with flared tail and widely spread pinions, this Red-tailed Hawk is hunting for a thermal. Red-tailed Hawks routinely experience what earthbound humans can only dream of. Rising columns of warm air provide what is essentially a free ride for hawks and other birds to ascend to a lofty observation point from which they can scan the landscape for many miles with the best eyes on the prairie.
Kingfisher Co., Oct. 30, 2009

Even on Oklahoma's relatively flat topography, birds of prey can get lift from air deflected upward as it pushes against hills, highway overpasses, and reservoir dams. Some elevated limestone and sandstone ridges on the prairie, especially those that face southwest, are magnets for local wind riders.

Noble Co., Jan. 24, 2010

If you go hawk watching early on a still winter day you will not see many hawks high in the air. The ones you do see flying will be flapping heavily with deep wing beats because flying is more difficult in the thick, still morning air. However, about midmorning as the sun gets higher and the earth begins to warm, columns of warm air start to rise. These rising columns of warm air are known as thermals, and for a Red-tailed Hawk aloft on one of them they provide an essentially free ride. The hawk can scan many square miles easily and, from the height of its soar, glide away in a long, sloping descent with amazing speed and be a mile away in seconds. For most birds of prey, distance is only a minor inconvenience.

Red-tailed Hawks are frequently seen soaring with other birds. American Crows seem to be quite fond of rising on thermals with Red-tailed Hawks and playfully tormenting them, although they must do so with caution since a Red-tail could easily kill one if it could catch it. On one memorable occasion in early spring I watched an adult Red-tailed Hawk soaring with a very large bull snake still writhing as it dangled at least three feet beneath the circling hawk. Soaring with the hawk were a couple of crows that took turns pecking at the twisting tail of the serpent.

If human intrusion into their winter territories is prolonged, such as when ranchers or farmers are working near them, Red-tailed Hawks will often soar up high where they feel safe and just observe the intruders until they leave the area. Many times over the years I have watched through my truck's rear window as they drop very quickly from their spirals and gracefully descend back to their perches, ruffle up a little, and get back to hunting.

Another kind of free ride for Red-tailed Hawks and other soaring birds forms when prevailing winds strike the windward sides of big landscape features, which in north-central Oklahoma's fairly flat landscape include things such as hills, bluffs, turnpike overpasses, and reservoir dams. The wind is deflected upward by these big objects and forms a pillow of air that hawks can float on. On these deflected winds they can stay stationary quite easily to hunt or just to see what's going on around them.

Although there are other birds of prey that are much faster in both dives and level flight, Red-tailed Hawks are still deceptively fast. They can put distance between themselves and a human on foot or one getting out of a vehicle with amazing speed if they so choose. One thing I know for certain after many years of working hard to get fairly close to them to get a picture is that any Red-tailed Hawk can easily outrun a Toyota pickup.

No arrow can reach him; nor thought can attain
To the placid supreme in the sweep of his reign.
—*Herman Melville*

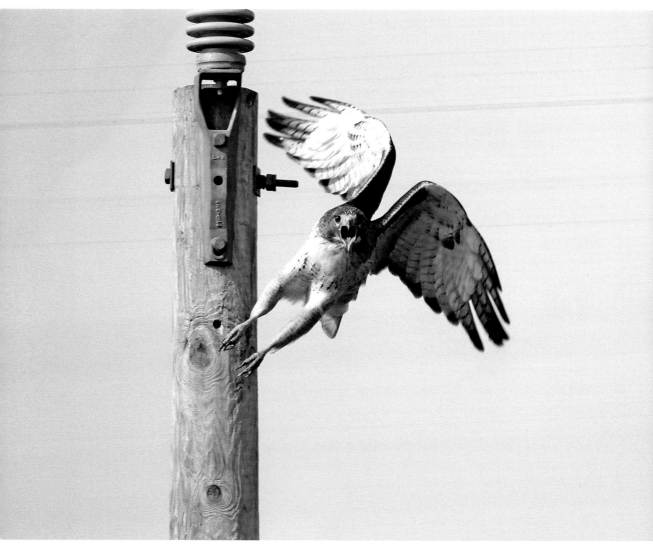

Most all Red-tailed Hawks encountered on the prairies of Oklahoma are extremely wary of humans, but while in the process of putting distance between themselves and you, many will complain vociferously at your presence.

Grant Co., Nov. 18, 2010

The Defiant Red-tail

You would think that the interesting lives and amazing colors of Red-tailed Hawks would be plenty to keep an inquisitive naturalist occupied, but there is another aspect of these birds that is downright entertaining: their personalities. They really interact with you. Red-tailed Hawks are extremely vocal. I have never stopped to assess what percentage of the time Red-tails scream at you when you interrupt what they are doing, but I would say it's well over half of the time.

Even if you think you have never heard the call of a Red-tailed Hawk, chances are nearly 100 percent that you have unless you never watch television or go to the movies. Virtually every time the call of a raptor is required for some movie or television show, it is the recording of a Red-tail that comes to the rescue. Even in the movie version of J. R. R. Tolkien's *Lord of the Rings*, the eagles that rescued the hobbits from the fiery slopes of Mount Doom were accompanied by the calls of, you guessed it, the Red-tailed Hawk. There are a couple of reasons for these hawks' popularity in the movies. First, they are easy to record. Just walk into one's nesting territory or bump one off its hunting perch in the winter and it will probably complain loudly. Second, the character and quality of that drawn-out, raspy scream is the essence of what a bird of prey should sound like. However, I have noticed that the call of the Hollywood Red-tailed Hawk is often more exaggerated and echo enhanced compared to the ones I hear in Oklahoma. So, whether it's a Bald Eagle soaring, a Peregrine Falcon diving, a car commercial that needs a wild sound, or a desolate canyon scene in some western movie—cue the Red-tailed Hawk.

I have a long route that winds through the prairies of north-central Oklahoma and passes through the winter territories of some of my favorite hawks. I take it regularly from early October through mid-March. You would think that over the years those birds would get pretty used to me and tame down a little. Unfortunately, the opposite is true. They remember me and can spot my pickup at a great distance, and since they know I am going to slow

down and look at them, they get quite upset; basically they hate me. Some are exceptional screamers and treat me to a nonstop vocal barrage until I leave the area, smiling and shaking my head at their antics.

So how do we know these vocalizations are the equivalent of a Red-tailed Hawk tongue lashing? The answer is not difficult: these extremely territorial nesting birds give the exact same call to interlopers that they often grapple and fight with over living space, their most valuable possession.

The call of the Red-tailed hawk is not popular with just humans. The common Blue Jay, a very intelligent bird, frequently mimics the hawk's call. It mimics it so well that even after my many years in the field with both birds they frequently manage to fool me. Typically after a few fake calls I catch on, especially when the Blue Jay switches to its more common squeaky-hinge call as if to say, "Gotcha!" European Starlings are also a darned good mimic of Red-tailed Hawk calls, but they turn the volume way down and are not nearly as likely to fool you as the Blue Jay.

Life is simple in the mind of a Red-tailed Hawk. It's their sky, their field, their perches, and their home. They were there first and don't mind telling you so. Their tendency to be so vocal is one of their most endearing qualities.

Red-tailed Hawks and Northern Bobwhites

What Oklahoman does not miss the cheery call of the Bobwhite? They were once so abundant you could barely step outside in any rural area in spring without hearing their distinctive call. They are not gone, but they nearly are.

There is no mystery about their disappearance. They are one of the most studied game birds, and wildlife biologists understand them well. Unlike the Red-tailed Hawk, which has benefited from modern humans' activities, Bobwhites have been negatively affected. Human-caused habitat changes have been steadily reducing the areas that Bobwhites need to thrive. They need a mixture of cover for forage and for escaping from predators and inclement weather. But such conditions have disappeared throughout much of their range, and not just in Oklahoma; the Bobwhite decline is widespread.

The familiar call of the male Northern Bobwhite is rarely heard nowadays on the Oklahoma prairies. Loss of habitat and sequential droughts have resulted in a widespread descline of this beloved bird across most of its former range.
Image by Tom J. Ulrich

Unlike Red-tailed Hawks at the top of the food chain, Bobwhites are near the bottom; everything likes to eat them. The relationship between quail and predators is complicated. John Muir, one of America's great naturalists, said it best: "When one tugs on one part of nature one finds it is connected to everything else."

One of the best explanations of the Bobwhite-predator relationship is provided by the Missouri Department of Conservation publication "On the Edge: A Guide to Managing Habitat for Bobwhite Quail," which says:

> An important finding is that many of the quail's enemies eat other quail predators. Research in the 1990s in Missouri and other states identified snakes as a major consumer of quail eggs. Even rodents, particularly cotton rats, take a toll on quail nests. Fortunately for quail and their enthusiasts, predators such as hawks, owls, coyotes and bobcats help keep these egg eaters in check. The image of a round-bellied fox, coyote or hawk belching quail feathers is a handy scapegoat, but it's inaccurate.
>
> In fact, the red-tailed hawk, which is often blamed for quail problems because it is so conspicuous, probably does far more good than bad for quail. First, red-tailed hawks prey heavily on snakes, the destroyer of many quail nests. Second, these hawks displace Cooper's hawks, a species supremely adapted to preying on quail. Similarly, coyotes take relatively few quail, but they displace the more serious nest predator, the fox.

I am no old-timer, but in my time growing up and living in Oklahoma I have witnessed a lot of changes on the landscape. The Greater Prairie Chickens we hunted in Ottawa County where I grew up are gone. The Greater Prairie Chickens in Noble County where I have watched winter hawks for many years are essentially gone, and with them the Golden Eagles that hunted them. Black-tailed jackrabbits are very rare nowadays, but when I was a kid they were everywhere, even in far eastern Oklahoma. We now have white-tailed deer in abundance where there were few before. And beaver are now so numerous they are considered a pest. There is little doubt that humans have caused all of these changes. The Bobwhite, however, once so abundant and now so rare, is perhaps the most dramatic disappearance yet and reminds us just how fast things can change. The Bobwhite may just be the canary in the coal mine.

Quail and Red-tailed Hawks have coexisted for millennia, and Red-tailed Hawks will certainly kill quail if they have the opportunity; however, the hawks did not eat the quail into oblivion and are not the cause of the widespread quail decline. Unfortunately for the hawks, they are the most abundant and conspicuous predator on the prairie landscape, especially in winter, and therefore they get the blame and the bullets.

The Amazing Diversity of Red-tailed Hawks

Red-tailed Hawks come in a bewildering assortment of plumages. The different types are called subspecies or races, and most all of the main varieties can be seen on the southern Great Plains in winter. Learning to identify the different types in the field is extremely challenging, even for experts. Many simply cannot be classified.

There is in the United States a very small but extremely enthusiastic group of died-in-the-wool students of variation in Red-tailed Hawks. If you want to start a nasty food fight with this bunch, just start talking about the various types, where they come from, how they can be separated from the other types, the exact ranges they occupy during the breeding season, and so on. Everybody has his or her own pet theories. Many objective members of this small group admit freely they just do not have enough information to completely understand this aspect of Red-tailed Hawks, at least not at this time. In fact, the variation in Red-tailed Hawks has barely been studied on their nesting grounds, but it is known that the traits of each type are not unique and that they are to some extent shared by the other types. These blended Red-tailed Hawks of dubious lineage are frequently referred to as intergrades. Leave it to the Red-tailed Hawk to make such a puzzle for us humans to solve. The realm of biology that deals with the classification of different organisms into related groups is called taxonomy. This field is being revolutionized by modern molecular biology, so perhaps many discoveries in Red-tailed Hawk classification are on the horizon. The Red-tailed Hawk makes me happy that I am an ecologist and not a taxonomist. Red-tailed Hawk taxonomy is a very slippery slope indeed.

Trying to guess the race of a particular Red-tailed Hawk when many are jumbled together on their wintering grounds requires a lot of guesswork because, except for some, you never really know where they came from. One thing I have learned is to never say "never" or "always" when it comes to Red-tailed Hawks.

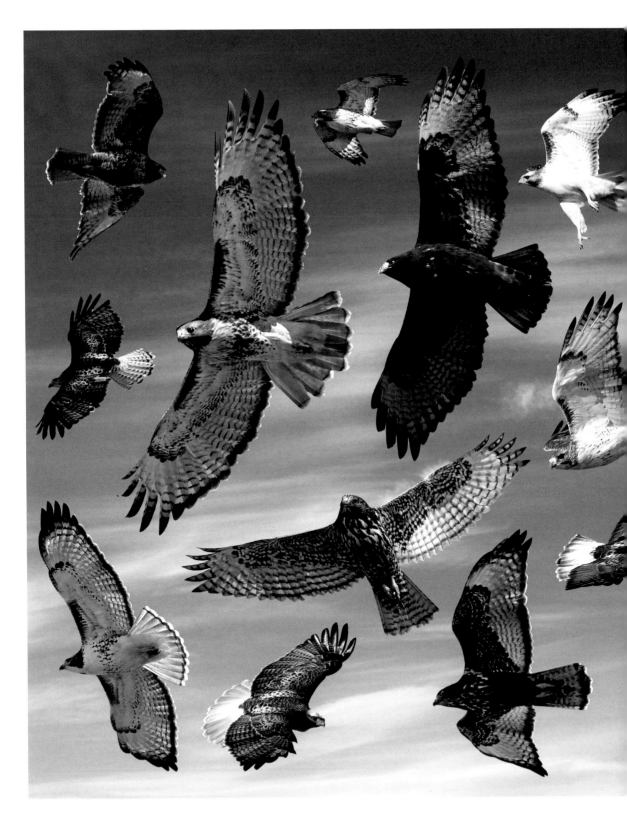

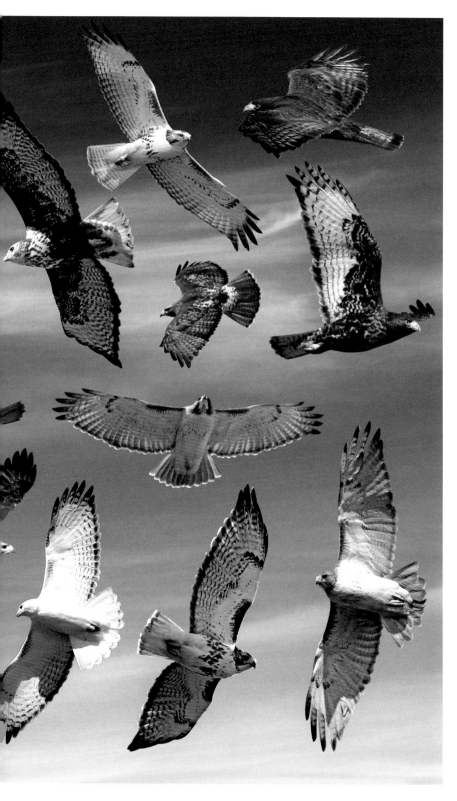

Red-tailed Hawks are remarkable in their bewildering variation of color and plumage patterns. The types are known as subspecies or races, and they come to Oklahoma from across a wide area of northern North America.

The Diversity of Red-tailed Hawks

Biologists refer to birds that display such a wide variety of colors and feather patterns as polymorphic, which means "many forms." The Red-tailed Hawk gives polymorphism a whole new meaning. I do not know of a single other species of bird in North America that shows such a range of variation. This is why it is so easy to recognize some individuals from year to year in winter. When I show my Red-tailed Hawk photographs to people they are likely to say something like "Those can't all be Red-tails, they are so different." The real head-scratcher question for biologists is, why? Why do they show such variation and how does it benefit their species? We may never know.

Modern digital photography and the Internet are perhaps the most important recent technologies that have given us a better understanding of Red-tailed Hawk variation. The new high-tech cameras and lenses make getting quality images of these birds light-years easier than it was in the days of film, and the Internet provides the opportunity to instantaneously share images with others around the country. A Red-tailed Hawk photographed in Oklahoma roosting peacefully during the day out on the prairie could easily have its image flashed across the country to many individuals before the sun rises the next day.

It is almost impossible to talk about Red-tailed Hawks without addressing their amazing variation. If you want to learn more about plumage variation in the races of Red-tailed Hawks, get ready for some work. There are several very good raptor guides that go into great detail on this topic. However, if you want to get started trying to identify some on their Oklahoma wintering grounds, which is an excellent place to do so, the following chapters will introduce you to the topic.

Before Tails Turn Red

If you are new to hawk watching and want to learn about Red-tailed Hawks, it is essential for you to be able to tell the difference between adult and young Red-tailed Hawks. It's not hard at all. The young are typically referred to as juveniles, immatures, hatch years, or first years. The most important difference between them is in the coloration and markings on the topside of the tail. Basically, most immature hawks have dull brownish, multibanded tails and most, but not all, adults have bright, brick-red tails. Occasionally, young Red-tailed Hawks fledge from the nest with tails as red as those of adults, but this is rare. The problem with distinguishing adults from juveniles is that sometimes

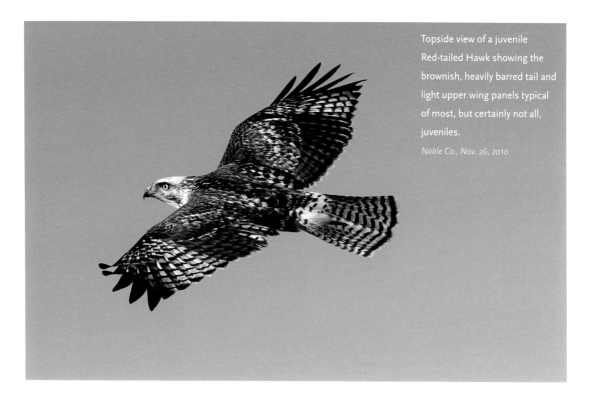

Topside view of a juvenile Red-tailed Hawk showing the brownish, heavily barred tail and light upper wing panels typical of most, but certainly not all, juveniles.

Noble Co., Nov. 26, 2010

Adult Red-tailed Hawks

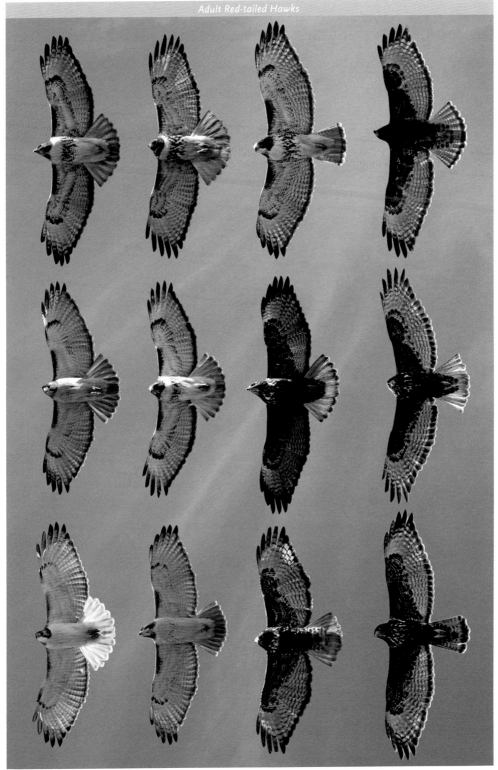

Underside views of adult Red-tailed Hawks of various races. Note the great variation in tail patterns and color but the consistency in the dark trailing edges of the wings.

Juvenile Red-tailed Hawks

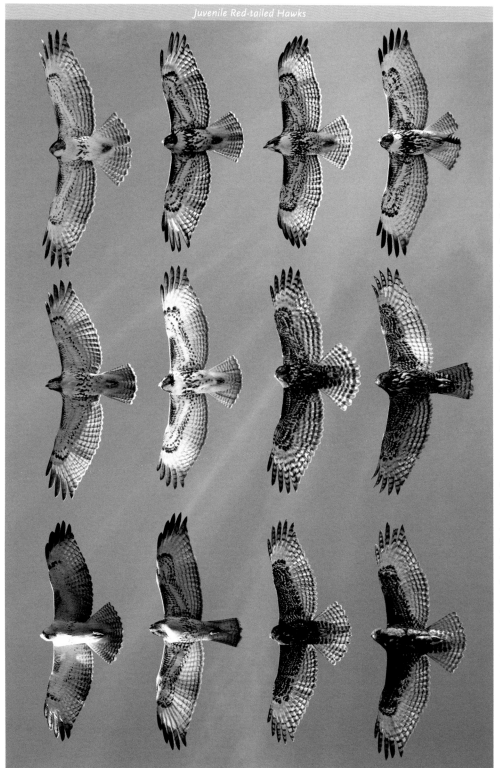

Underside views of juvenile Red-tailed Hawks of various races. Note that all have heavily barred tails and very light trailing wing margins.

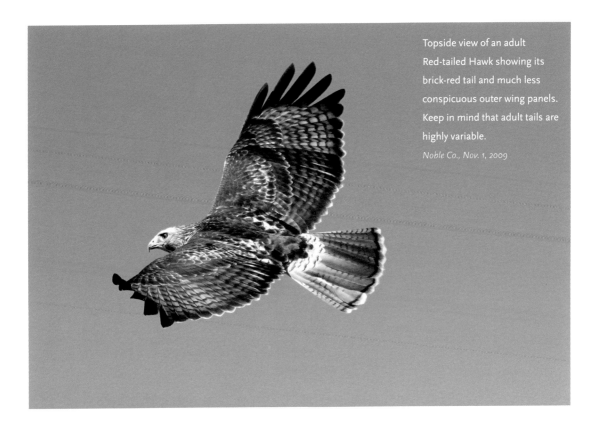

Topside view of an adult Red-tailed Hawk showing its brick-red tail and much less conspicuous outer wing panels. Keep in mind that adult tails are highly variable.

Noble Co., Nov. 1, 2009

you do not get a good look at the tail's topside, especially when the hawks are sitting and facing you or soaring overhead, or when the lighting is poor. However, there are more subtle differences between these two groups that you can learn quite easily and use in the field.

The markings and the shape of the wings while in flight are the key to telling the difference if you can't see the top of the tail. Young Red-tailed Hawks have narrower wings compared to the relatively broader wings of adults. The narrow wings of immature hawks give them a lanky appearance that is very conspicuous, even at a distance. In addition to wing shape there are markings that can be used to tell them apart. In almost all adult Red-tailed Hawks the entire trailing edge of the wing has a bold blackish or dark gray margin that is about 1–1.5 inches wide and contrasts sharply with the inner parts of the wing feathers. This dark margin is very conspicuous when viewed from below. Young Red-tails only very rarely have this dark margin. Another wing feature, which can be observed at quite a distance, is the light-colored contrasting panels seen toward the ends of the wings on the topside. These panels are not as noticeable in adults. Young Red-tails also have longer tails, which can be conspicuous even at a distance.

If you are a careful observer and know what to look for, you can sometimes

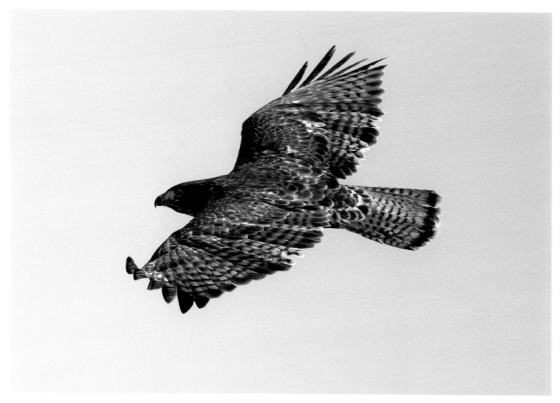

Sometimes Red-tailed Hawks in their second winter can be identified by their mixture of juvenile and adult feathers. By their third winter they will show a complete set of adult feathers and will be impossible to distinguish from even the oldest birds.
Garfield Co., Dec. 26, 2010

spot Red-tailed Hawks that are in their second year of life. Some Red-tails, after their first molt, retain a few of their first-year feathers mixed in with their new adult feathers. First-year wing and tail feathers are noticeably more worn and weathered than the first generation of adult feathers that replace them. They are also a different length, so the trailing edges of the wings of second-year birds can appear notched or very uneven compared to the smoother edges that most fully feathered adults show. I suppose that in rare instances the birds might carry some first-year feathers into their third year. Once past the two-year mark, though, Red-tailed Hawks hide their age.

Finally, if you are close enough to look them in the eye you will notice that the irises of young birds are lighter than those of most adults, which have beautiful, very dark brown to black eyes. The problem with using eye color to assess age is that it takes a few years for the eye color to darken, so some young adults still have very light irises. Study the photographs presented here and you will find that in most cases and under good lighting conditions young hawks are easy to distinguish from adults.

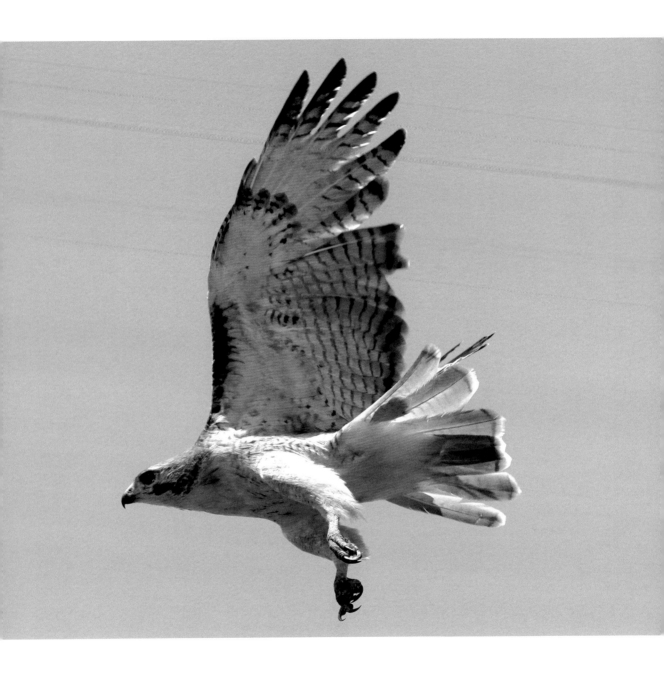

Meet the Locals

When Red-tailed Hawks from northern latitudes flood into Oklahoma in the fall they add to our local, nonmigratory population of Red-tailed Hawks. Our locals are sometimes difficult to tell apart from migrants, so you have to spend some time looking at locals during the breeding season to identify their territories and get to know their habitual hunting perches, which they will also frequent in winter. With the opportunity to watch the locals year-round you develop a good eye for what looks different when the migrants come down in the fall. Our locals are the yardstick, so to speak, with which the others are compared and are therefore the best subjects for starting to learn the different types. The majority of our resident Red-tailed Hawks have underbodies that are very lightly marked and breasts with fine streaking or almost no streaking at all, especially males. In the field, it is usually only during close encounters with our locals or with views through binoculars that the breast streaking is noticeable on most individuals.

Our local light-breasted hawks are perhaps a type of Red-tailed Hawk that breeds across much of the Great Plains, but more studies are needed to determine where they fit in. The north-central counties of Oklahoma that I am most familiar with appear to be in a zone where two types of Red-tailed Hawk intermix. One, called the Fuertes Red-tailed Hawk (*Buteo jamaicensis fuertesi*), occupies a breeding range in the southwestern United States and northern Mexico and historically was found as far north as Oklahoma. The other is the Eastern Red-tailed Hawk (*Buteo jamaicensis borealis*), whose large breeding range covers the entire eastern United States, parts of the Great Plains, and a large part of Canada.

Historically, the Fuertes Red-tailed Hawk has an interesting Oklahoma connection. Oklahoma's most famous ornithologist was the late George Miksch Sutton, from the University of Oklahoma at Norman. Not only was he a very observant field biologist, he is also recognized as one of America's leading bird artists. Known to everyone simply as "Doc," Sutton learned to

(Opposite) A resident Red-tailed Hawk. About the time their young fledge in spring our resident hawks begin their annual molt. Most will not be in perfect feather again until late fall. This bird exemplifies our typical Fuertes type resident with very light streaking on the breast. As is usual with Red-tailed Hawks, there are plenty of exceptions. Note the broken toe.
Kingfisher Co., June 16, 2010

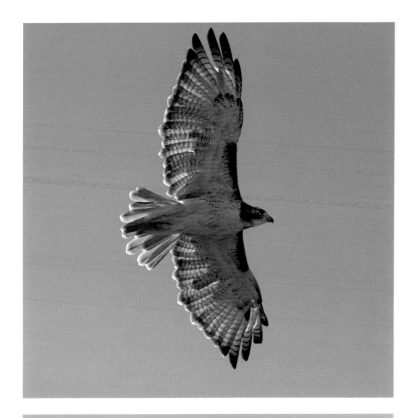

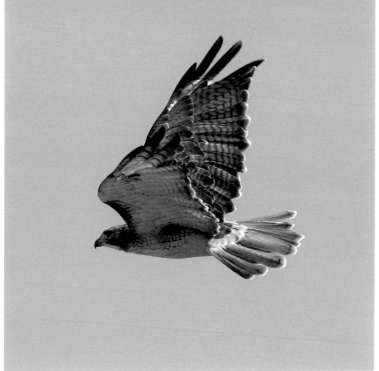

Two views of a resident Red-tailed Hawk. The light shining through its translucent wings and tail highlights the beautiful result of the orderly and symmetrical process birds go through annually to replace their most important assets: feathers. Though these images were not taken during the breeding season, the individual pictured is a member of a regularly observed pair, and the September date would be very early for migrants.

Noble Co., Sept. 29, 2013

paint birds from the greatest bird artist of his day, a man named Louis Agassiz Fuertes. Fuertes is considered to be right up there with John James Audubon with respect to his contribution to bird art in America. While on a field trip to southwestern Texas in the early 1930s Sutton noticed that the Red-tailed Hawks breeding in that area were much different from those he had seen in the eastern United States. According to the rules of biology if you discover an animal new to science you get to name it, so Sutton named this new type of Red-tailed Hawk after his famous artist mentor. When he moved to Oklahoma in 1952 he noticed that the same type of hawk he had discovered in southwestern Texas also nested across much of Oklahoma. It was later discovered that this same hawk nests throughout much of the southwestern United States and down into northern Mexico.

In *Oklahoma Birds*, Sutton clearly states, "The form [of Red-tailed Hawk] that breeds throughout the state is very lightly streaked on the lower breast and belly and is similar to *B. j. fuertesi* from Brewster County Texas." Brewster County, Texas, was where Sutton first discovered this type of Red-tail. Twenty years after the publication of *Oklahoma Birds*, and with much field experience in Oklahoma under his belt, Doc made an even stronger statement about the Fuertes Red-tailed Hawk in Oklahoma in his book *Birds Worth Watching*: "The geographic race of the Red-tail that breeds throughout Oklahoma is *Buteo jamaicensis fuertesi*."

In recent years some Red-tailed Hawk aficionados have written that here in Oklahoma all we have are plain old Eastern Red-tailed Hawks—they are just very light ones. My opinion is that confusion has arisen on this topic because much of the literature by Sutton and many other prominent ornithologists of the last century has been completely ignored or overlooked in recent publications, without any explanations as to why breeding range maps were changed. Also, the defining plumage characteristic that separates Eastern Red-tailed Hawks and Fuertes Red-tailed Hawks is the degree of streaking on the breast, and Sutton did not clearly define the break-off point between the breast streaking of the two types, though he clearly considered our resident birds to be the Fuertes type. The question becomes, how much streaking does a Fuertes have to have before it crosses the line and is called an Eastern? And then, we need to know which Eastern we should compare ours with, because the Eastern race is quite variable. It is possible that things have changed since Sutton's day and that tree encroachment on the prairies has allowed the typical Eastern Red-tailed Hawks to mix more with Fuertes Red-tailed Hawks on the southern plains. So for us Okies, whether you call our locals Fuertes Red-tailed Hawks or Eastern Red-tailed Hawks is, like so many other aspects of Red-tailed Hawk taxonomy, more interesting than it is important. It is the lives of Red-tailed Hawks that are so fascinating, not what

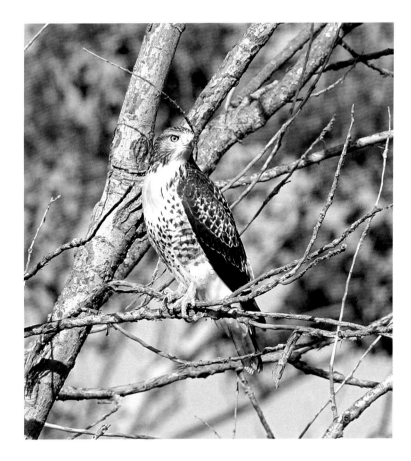

Doc Sutton, in his book *Birds Worth Watching*, remarks that many of our young Fuertes Red-tailed Hawks, fresh from the nest in summer, are quite heavily marked with brownish or black streaking on the belly as shown by this beautiful and near perfect young hawk.

Logan Co., June 11, 2014

names we give them or how we choose to sort them into groups on a museum tray; people could argue about that forever.

Imagine living out in the country enjoying the solitude, knowing most of your neighbors and getting along with them pretty well, when all of a sudden out of nowhere people start moving in all around you. That's exactly what happens to our local Red-tails in fall when the northern birds start to move in.

Our resident white-breasted hawks are almost always top guns in the winter Red-tailed Hawk landscape, and they reign supreme over all other Red-tailed Hawks in their blue domain. They allow other wintering adults to pass over their territories at a certain high altitude, but at lower elevations they severely punish the intruders for territorial intrusions. Murder is legal in their world, but it very seldom comes to that. They fight with the newcomers quite a bit when they first arrive in the fall by diving and chasing them all around, but eventually they all adjust into a state of uneasy coexistence and for the most part get along. Sometimes when you drive through winter hawk territories you bump them all off their hunting perches and mess up the territorial equilibrium. To avoid the human in the approaching vehicle the winter birds

(Opposite) Although most of our resident Red-tailed Hawks are very lightly marked below, this beautiful male bird from Kingfisher County, photographed in mid-summer, is lighter than most.

June 11, 2014

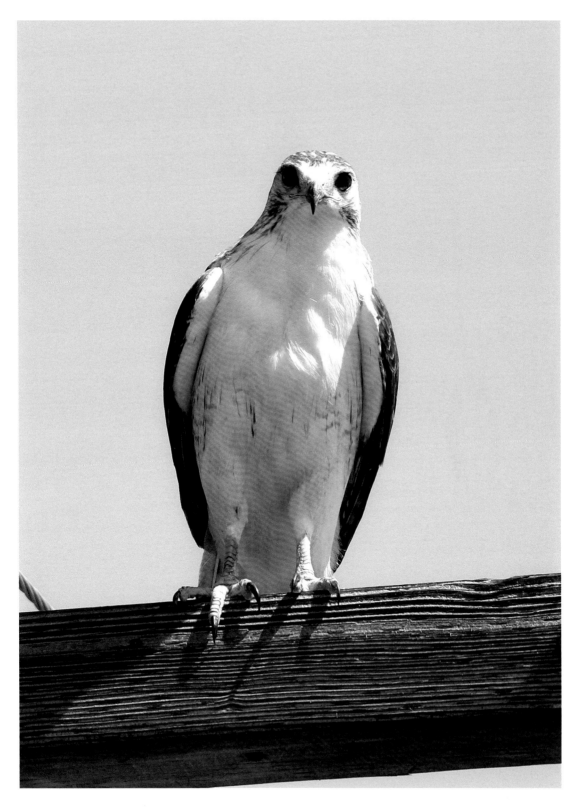

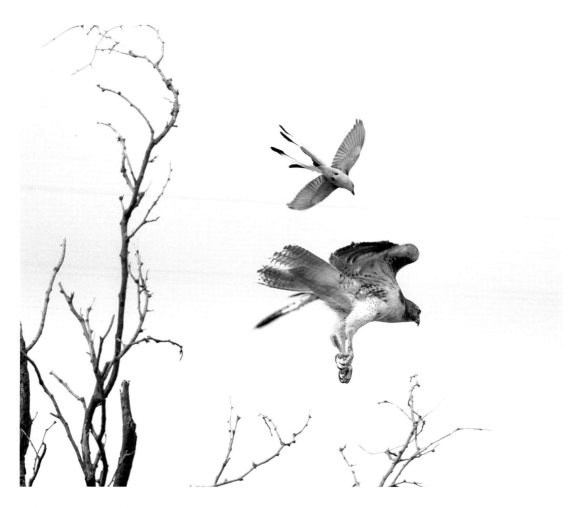

will fly away very briskly and will unintentionally get forced into the territory of a local. Usually both members of the resident pair come out to deal with the intruder and chase it away.

Another good way to recognize the locals out on the prairies is to notice where you see them. Most of the time, they claim all of the Red-tailed Hawk real estate along the small creeks and streams out on the grasslands. They typically sit in very conspicuous high perches within their highly defended territories. They usually spread themselves out quite evenly at about one pair per mile along these small waterways. Like some of the wintering adults, they are also frequently observed sitting very closely together, sometimes within one foot of each other. Our locals usually nest in the tall cottonwoods and elms that border these streams, and their nests are obvious in the winter when the trees are leafless.

In northern Oklahoma, almost always by early to mid-February, sometimes earlier depending on the weather, they can be seen carrying

Oklahoma's beautiful state bird, the Scissortail Flycatcher, is long on grace and color but very short on patience when it comes to hawks and crows anywhere near its nest. Like all members of the kingbird family, especially those that live in open country, they have a reputation for being pugnacious. Scissortails have no reservations when it comes to attaching themselves to the back of a flying Red-tiled Hawk and riding it for a great distance while pecking at the back of the hawk's head.

Noble Co., June 7, 2014

sticks and building up their soon-to-be-used nests. They are also frequently seen performing their very distinctive courtship flights at this time of year. These flights are impressive and beautiful. Typically the smaller males and the females soar high over their territories. The male shows off by displaying a series of dramatic high-speed dives followed by an ascent up to his original altitude. Both male and female dangle their legs as they soar in wide circles. Loud screams and softer calls often accompany the flights. Eventually the male approaches the female from above and often touches her or gently grasps her on her back. Sometimes they lock feet together and plummet to near ground level, cartwheeling as they fall. Just above the ground they unlock their feet and spiral back up. In early spring, even our winter visitors can be seen performing this ritual, apparently anxious to begin their family-rearing efforts on territories a thousand miles or more from Oklahoma.

Usually by mid-March our locals are well into their breeding cycle and most are incubating eggs. From January until April, when our locals are very intent on their domestic activities, there are plenty of wintering birds around and so there are typically more aggressive interactions between locals and migrants. Because the nests of our locals are so exposed, the biggest threats

The abandoned telegraph poles along the Burlington Northern Santa Fe railroad are a regular hangout for this pair of resident Red-tailed Hawks.
Noble Co., Nov. 11, 2011

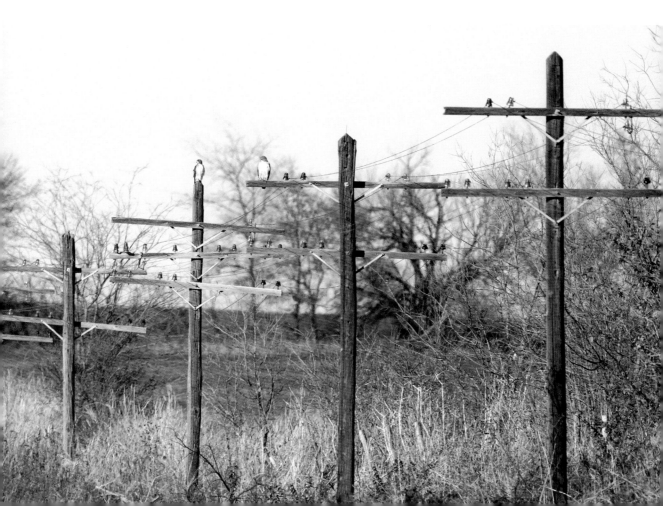

to their eggs and young are Oklahoma's violent spring storms, which will often destroy most of the nests in the path of the high winds and hail. The birds can start over again with a new brood, however, if their first nest is destroyed fairly early in the season. Many pairs of Red-tailed Hawks nest in the same tree for decades, attesting to the strong attachment these birds have for their homes.

The nest of a Red-tailed Hawk in a pecan tree on the open prairie.

Noble Co., Jan. 17, 2015

Eastern Red-tailed Hawk

Buteo jamaicensis borealis

Eastern Red-tailed Hawk.

Noble Co., Dec. 30, 2011

Noble Co., Mar. 4, 2014

(Above and opposite) The Eastern Red-tailed Hawk is variable in appearance; some have very light markings below and others are quite dark. These images show Eastern Red-tailed Hawks with a range of light to moderate belly markings.

Throughout most of its very large range both east and north of Oklahoma, the Eastern Red-tailed Hawk is thought to be nonmigratory. It is mostly those individuals from the extreme northeastern United States, parts of central Canada, and parts of the most northern Great Plains states that must vacate their nesting territories and fly south to spend the winter where prey is available and the climate is fairly mild. There is very little difference in appearance between many Eastern Red-tailed Hawks and our local Red-tailed Hawks, and exactly where on the southern plains they blend together is

Payne Co., Nov. 6, 2009

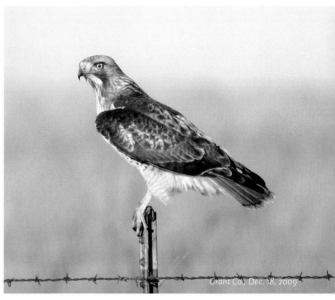
Grant Co., Dec. 18, 2009

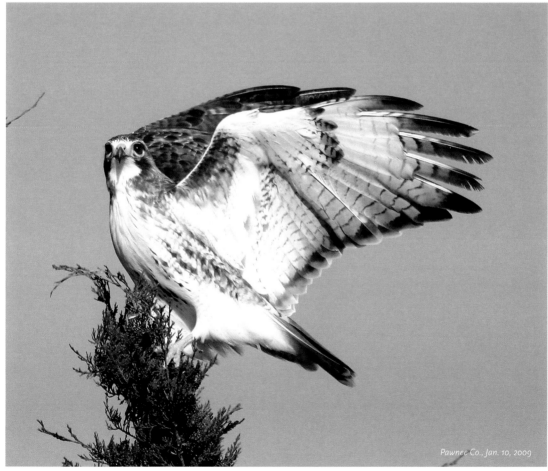
Pawnee Co., Jan. 10, 2009

poorly understood. Eastern Red-tailed Hawks are usually our most abundant wintering type, and they are more variable than our Fuertes Red-tailed Hawks. They range from very whitish and lightly marked on their underparts to some from throughout Canada that are very heavily marked on their underbodies. The latter are very abundant during most winters on the prairies of northern Oklahoma. They are known as Northern Red-tailed Hawks, or by the scientific name of their race, *abieticola*.

Just as the spreading of trees on the open prairies has benefited the Red-tailed Hawks of the southern plains, so also has the opening up of the eastern forest possibly benefited Eastern Red-tailed Hawks, which are probably much more abundant now than they were before Europeans settled there. Red-tailed Hawks prefer parklands with scattered trees or the edges of woods and forest, but not large tracts of unbroken forest.

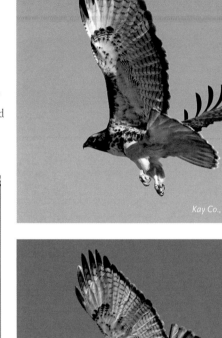

Kay Co., Nov. 5, 2010

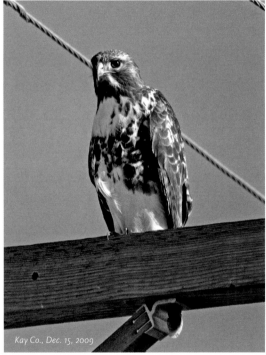

Kay Co., Dec. 15, 2009

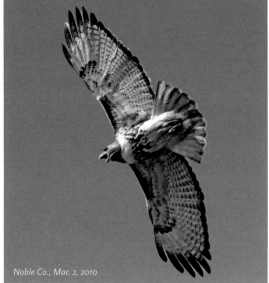

Noble Co., Mar. 2, 2010

(This page and opposite) **Some Eastern Red-tailed Hawks are very heavily marked below, as shown. This type is fairly common in winter on the prairies of north-central Oklahoma and is also known as the Northern Red-tailed Hawk. Most are from Canada.**

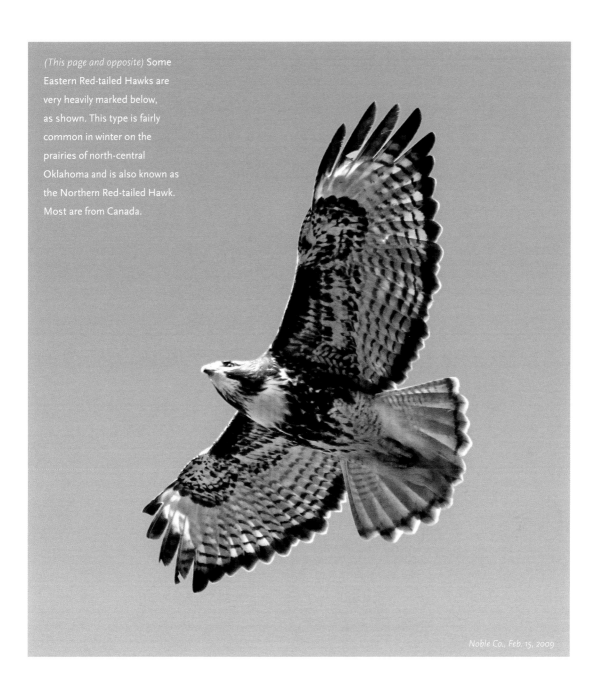

Noble Co., Feb. 15, 2009

Eastern Red-tailed Hawk

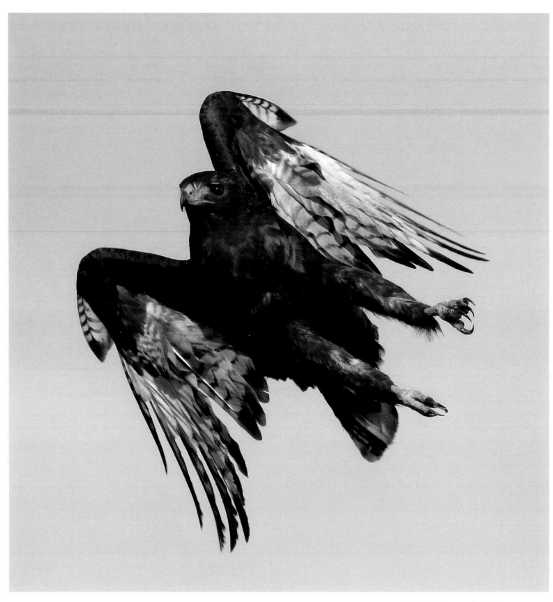

Adult dark-morph Western Red-tailed Hawk.

Noble Co., Nov. 11, 2011

Western Red-tailed Hawk

Buteo jamaicensis calurus

In Oklahoma in winter you might have trouble distinguishing our locals from some Eastern Red-tailed Hawks, but you should not have any problem distinguishing them from the majority of Western Red-tailed Hawks that drift in for the winter. When we think "western" we usually think of the American West, but that's probably not where most of the Western Red-tails that winter here come from. For the most part, adult Red-tails from most of the western United States are not migratory. You should more properly think of them as northwestern in origin because most of our Western Red-tails probably come from western Canada and Alaska.

Most Western Red-tailed Hawks are noticeably darker than our locals. These handsome hawks show a range of colors that are referred to as phases or morphs. Those at the very dark end are nearly black, very conspicuous, and quite striking. Adults of these very dark individuals usually have beautiful red tails with multiple heavy black bands. But again, as with all Red-tailed Hawks, there are plenty of exceptions. In between the lightest and darkest coloration there is a distinctive reddish type called the rufous morph. Western Red-tailed Hawks are quite abundant in Oklahoma during some winters. However, don't count on Red-tails to make anything easy. Sometimes Western and Eastern Red-tailed Hawks are very difficult to tell apart. If you drive west through the Oklahoma Panhandle in spring when Red-tails are nesting, you will see a change from our resident Fuertes type Red-tailed Hawks to Western Red-tailed Hawks near Kenton, Oklahoma.

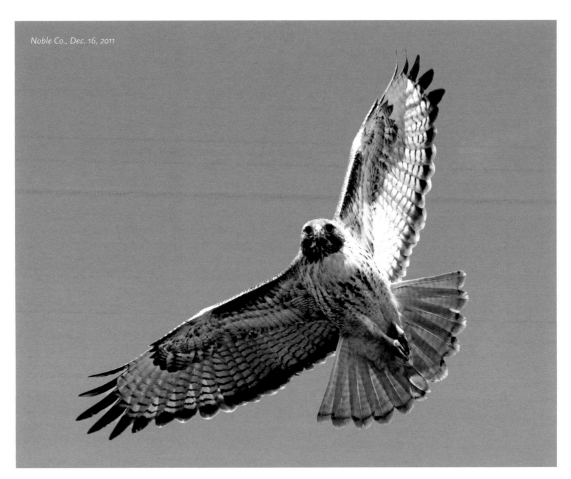

Noble Co., Dec. 16, 2011

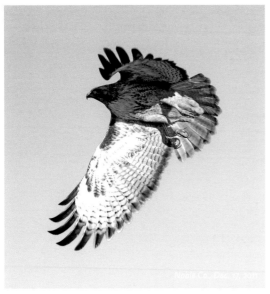

Noble Co., Dec. 16, 2011

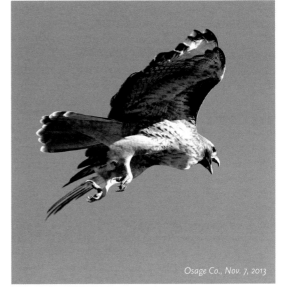

Osage Co., Nov. 7, 2013

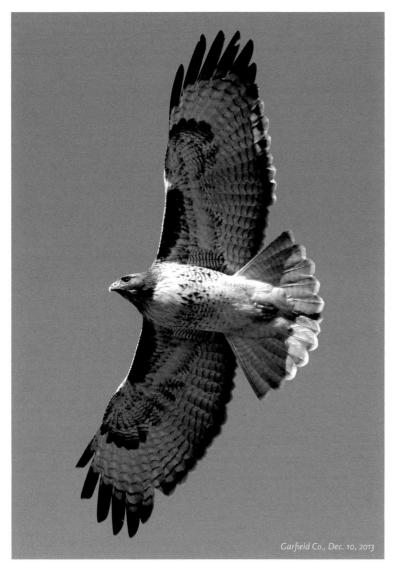

(This page and opposite) Western Red-tailed Hawks have color phases, or morphs, which range from light to very dark. These are light-phase adult Western Red-tailed Hawks.

Garfield Co., Dec. 10, 2013

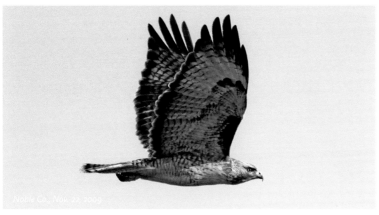

Noble Co., Nov. 21, 2009

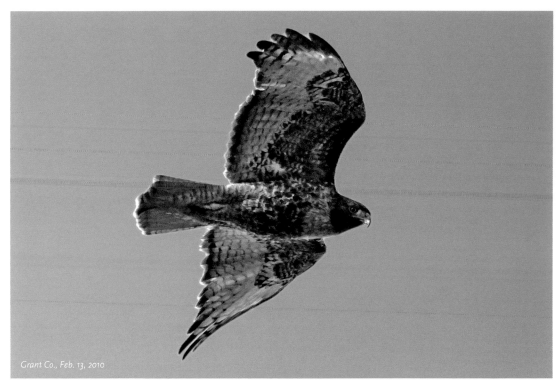

Grant Co., Feb. 13, 2010

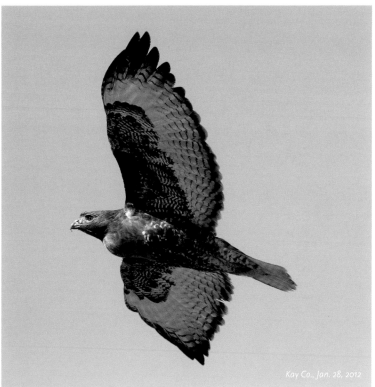

Kay Co., Jan. 28, 2012

(This page) The reddish or rufous morph of the Western Red-tailed Hawk.

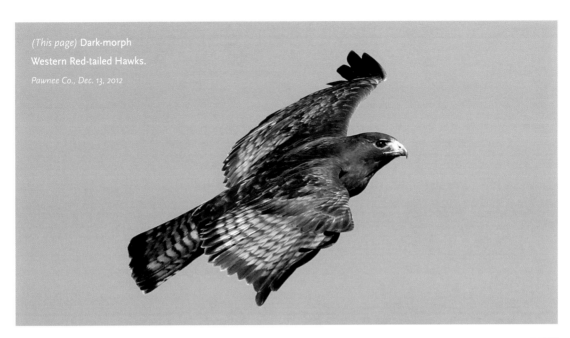

(This page) **Dark-morph Western Red-tailed Hawks.**
Pawnee Co., Dec. 13, 2012

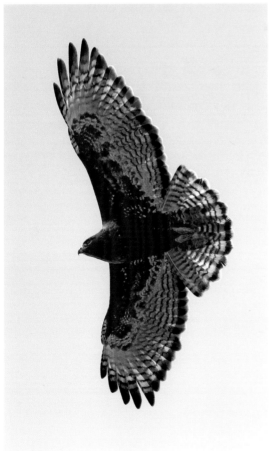

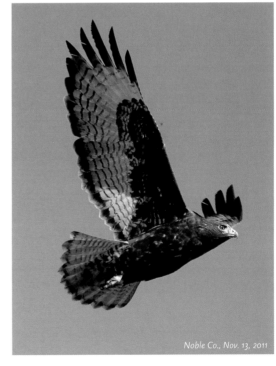

Noble Co., Nov. 13, 2011

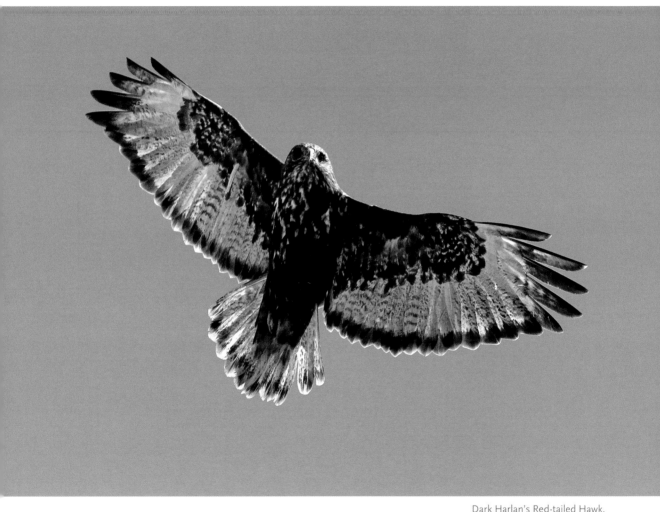

Dark Harlan's Red-tailed Hawk.

Noble Co., Feb. 5, 2012

Harlan's Red-tailed Hawk

Buteo jamaicensis harlani

One of the most variable and distinctive Red-tailed Hawks that winter in Oklahoma is the Harlan's Red-tailed Hawk, often called just Harlan's Hawk. In fact, Oklahoma could be considered "Harlan's Hawk central" during winter because we are well known for our fantastic wintering population. George Sutton's famous book *Oklahoma Birds* displays one of his beautiful watercolors, a portrait of a Harlan's Hawk, on the frontispiece. Another connection between Oklahoma and Harlan's Hawks is that perhaps the most comprehensive study of Harlan's Hawks on their nesting territories in Alaska was conducted by the late Craig Lowe, an Oklahoman. Most Harlan's Hawks are visitors from Alaska and the Yukon Territory of Canada. In general, they travel the greatest distance of any of our wintering Red-tailed Hawks and often arrive in Oklahoma very early in the fall. They also frequently stay late in the spring, sometimes well into April.

Most Harlan's Hawks are blackish. Some appear nearly jet black under field conditions, but they range from black to nearly white. The most distinctive and variable feature of Harlan's Hawks is their tails, which can have a reddish, blackish, or white background with patterns varying from mottled or speckled (the most common type) to heavily barred, lightly barred, both barred and mottled, tipped with red, tipped with gray or black—the variation goes on and on. They can even have normal, completely rufous-type tail feathers, like those of an Eastern Red-tailed Hawk, mixed in with the mottled Harlan's Hawk types.

Harlan's Hawks are an enigma and have confused ornithologists for decades because they show so much variation and are so different from most

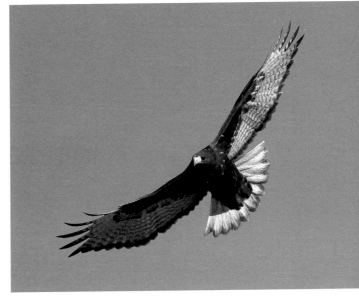

During most years wintering Harlan's Red-tailed Hawks are not hard to find on the prairies of Oklahoma. These hawks are notoriously variable in appearance. However, the blackish ones like this are the most common type.

Grant Co., Nov. 27, 2011

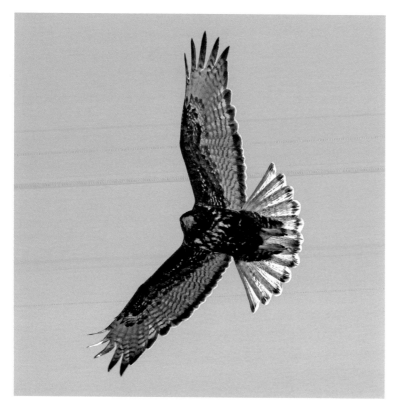

The tails of Harlan's Red-tailed Hawks are their most distinctive feature. Most are mottled like this one, but as the images in this chapter show, they are highly variable.

Grant Co., Nov. 26, 2010

other Red-tails. They have in the past been classified both as a separate species and as a race of the Red-tailed Hawk. They are currently considered to be a subspecies of the Red-tailed Hawk. Studies have shown that their DNA is nearly identical to that of the Eastern Red-tailed Hawk even though their outward appearance can be strikingly different.

We have lots of Harlan's Hawks in Oklahoma in winter, but they are still far less abundant than the Eastern and Western Red-tailed Hawks. Because they are so distinctive, they are easy to identify from year to year when many return to the same small areas. Also, many adults occur in pairs and appear to be mated, at least on the tallgrass prairies of north-central Oklahoma. Some of the winter hawk territories that I have observed for decades consistently have a pair of black or otherwise distinctive Harlan's Hawks occupying them.

I am pretty sure it is not my imagination, and of course most Red-tails are wary, but Harlan's Hawks seem to be extremely so. Adults are quite challenging to get close to for more than a few seconds; the very distinctive young are more approachable and less wary. I have taken quite a few pictures over the years of other types of adult Red-tailed Hawks that have calmly perched on fence posts as my vehicle either slowed down or came to a complete stop adjacent to them for just long enough to snap off a few frames, but this has never happened even once with an adult Harlan's Hawk.

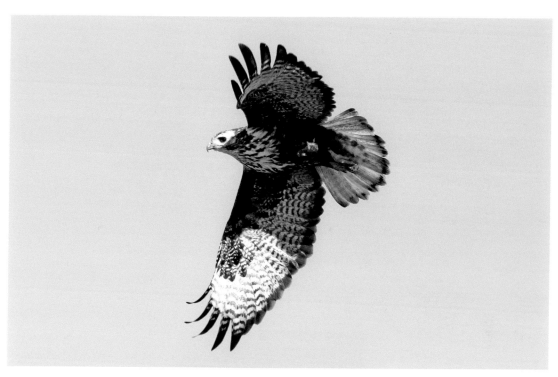

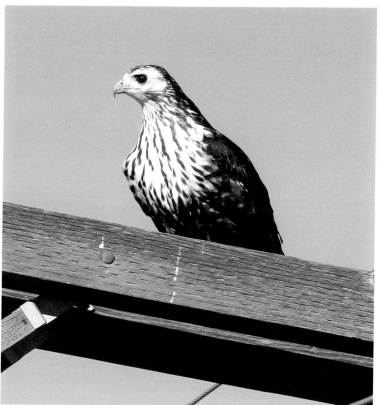

Some Harlan's Red-tailed Hawks are very striking and distinctive, like the individual shown here, and are easy to identify from year to year. This bird returned to the same few acres and used the same hunting perches for three consecutive years near Medford, Oklahoma.

Grant Co., both Nov. 26, 2010

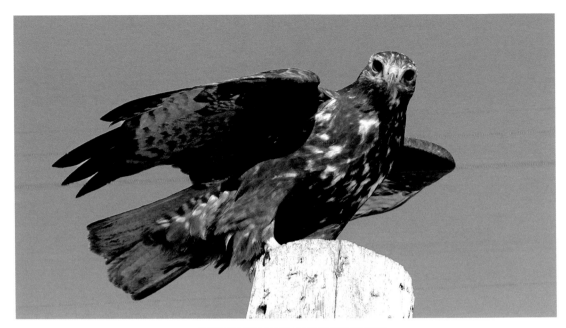

The name "Harlan's Red-tailed Hawk" has an interesting origin. The bird was discovered and named by none other than John James Audubon, the world's most famous bird artist. Audubon named this bird after his physician and friend Richard Harlan. This hawk is also referred to as "Black Warrior" in some of the older bird books, a fitting name for this dashing and impressive bird. In the opinion of many hawk watchers, Harlan's Hawks are one of the most desirable winter hawks to encounter. We are quite lucky in Oklahoma to be able to see so many of them in the winter.

Many times over the years I have noticed Harlan's Hawks in very close proximity to large flocks of Red-winged Blackbirds. In eastern Garfield County in January 2011, a group of these hawks kept my attention most of one afternoon as I watched them hunt one of these large

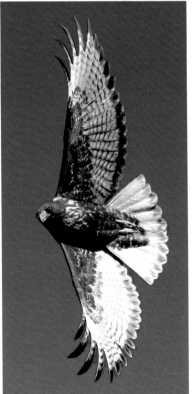

Very close encounters with Harlan's Red-tailed Hawks are extremely rare on the open prairies. These visitors from the far north are noticeably more wary than the other types that winter here. The white streaking on the upper breast is a common trait of most dark adults.

Noble Co., Nov. 30, 2011

Flaring hard into a stiff wind, this dark Harlan's Red-tailed Hawk's underwings show silvery in the low winter sun.

Grant Co., Nov. 26, 2010

blackbird flocks. On previous trips past a large winter wheat field I had seen perhaps nearly a million (just a wild guess) Red-winged Blackbirds feeding, and occasionally I would see a couple of black Harlan's Hawks perched near them. On this particularly frigid and windy day I stopped to watch this huge flock of blackbirds as they churned restlessly—landing briefly, then taking off in waves, then alighting again. I then noticed a couple of dark Harlan's Hawks cruising very slowly right through the flock while panicked birds whirled around them; but many others remained on the ground feeding, apparently unconcerned. The hawks cruised through in a surprisingly slow, relaxed fashion with heads looking straight down, obviously searching for a potential victim, perhaps the sick or injured. At a certain point the hawks descended to the ground, but the melee of flickering red and black wings blocked my view of what was going on at ground level. Seconds later I saw one of the Harlan's Hawks fly from the flock with a captured bird, which it carried in its beak to a nearby fence post and quickly devoured.

I watched in amazement for a couple of hours as four adult and one young black Harlan's Hawk repeatedly hunted and captured Red-wings. Once, all five Harlan's Hawks perched in the same small tree, all with bulging crops but still going back for more. Sometimes they

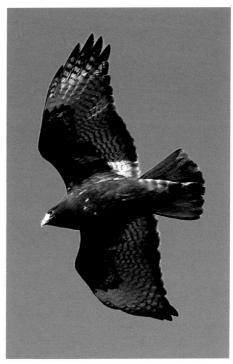

The name "Harlan's Red-tailed Hawk" was given this bird by none other than John James Audubon. Richard Harlan was Audubon's friend and physician. An older name for this bird is Black Warrior. Nearly jet-black birds like this one are very impressive.

Garfield Co., Nov. 27, 2011

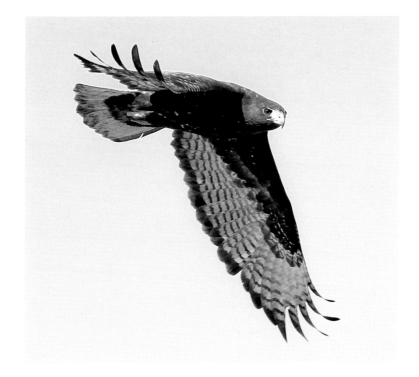

Harlan's Red-tailed Hawks have confused ornithologists for decades because they are so different from other Red-tailed Hawks. They are currently considered a race of the Red-tailed Hawk.

Grant Co., Dec. 18, 2013

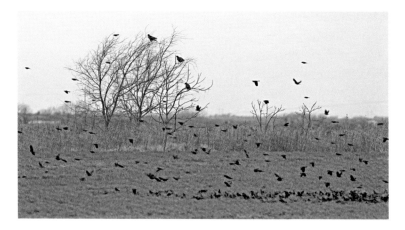

Three black Harlan's Red-tailed Hawks perched near a flock of Red-winged Blackbirds. On this day I observed as many as five Harlan's Red-tailed Hawks making frequent forays into this flock to capture blackbirds.
Garfield Co., Nov. 22, 2011

would sit right on the ground only a few feet from the foraging blackbirds. A juvenile Krider's Red-tailed Hawk, a juvenile Eastern Red-tailed Hawk, and several Northern Harriers also got in on the gorging. Two days later I came back hoping to see a replay, but to my disappointment the hawks and all but a few blackbirds were gone.

The reaction of the Red-winged Blackbirds to the marauding Red-tails was much different from their reaction to other raptors such as Sharp-shinned Hawks, Cooper's Hawks, or Merlins, all of which dine mostly

A marauding Harlan's Red-tailed Hawk searching for a potential kill slowly cruises through a flock of foraging Red-winged Blackbirds.
Garfield Co., Nov. 22, 2011

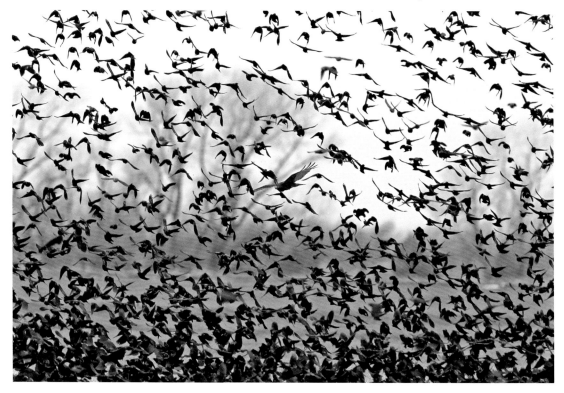

on birds. When these bird-hunting specialists hunt these large flocks of blackbirds, havoc reigns.

On another occasion, in Noble County, I flushed a black Harlan's Hawk near a roadside. At the spot where it flew from the ground I found a freshly killed Mourning Dove. Harlan's Red-tailed Hawks have smaller feet than most other types of Red-tails, so perhaps they are better adapted for bird hunting, which does not require the heavier armament needed for hunting larger mammals. There is no doubt, however, that cotton rats are the main fare of most Harlan's Hawks that winter here. The majority are seen out on the grasslands away from large flocks of birds and hunting the weedy roadsides, just like all the other types.

Because the blackish Harlan's Hawks are so distinctive, it is easy to interpret their interactions with our resident birds; they are the obvious interlopers. During winter I frequently see very aggressive interactions between them. Usually both members of a resident pair attack a Harlan's Hawk at the slightest territorial infringement. Once I watched a pair of resident birds relentlessly harass an adult Harlan's Hawk that made a bold direct flight into their territory to attempt (unsuccessfully) to catch something in the grass. They went after the interloper with a vengeance and chased it for quite a distance. After a period of being chased by the pursuers the Harlan's Hawk spiraled into a soaring pattern and ascended up to perhaps a thousand feet. Even at that altitude the resident birds kept chasing it. The event lasted about ten minutes but was finally broken up by an adult Bald Eagle that made a direct flight right at the Red-tails. It soared with them briefly, whereupon all three hawks began to dive at the eagle before gliding back to their territories. It is scenes like this that make raptors so exciting to watch.

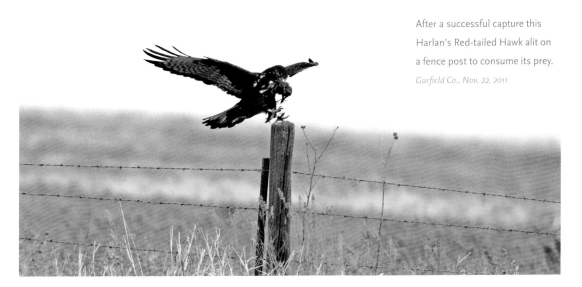

After a successful capture this Harlan's Red-tailed Hawk alit on a fence post to consume its prey.
Garfield Co., Nov. 22, 2011

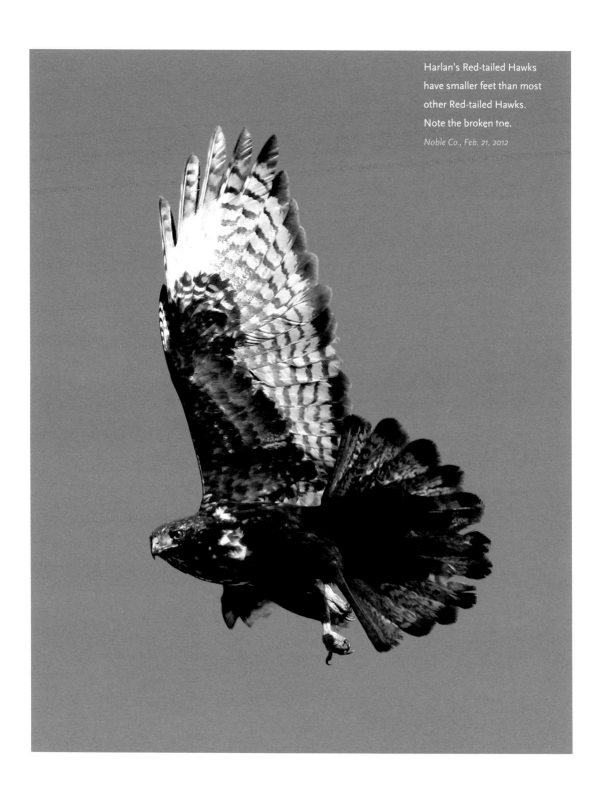

Harlan's Red-tailed Hawks have smaller feet than most other Red-tailed Hawks. Note the broken toe.
Noble Co., Feb. 21, 2012

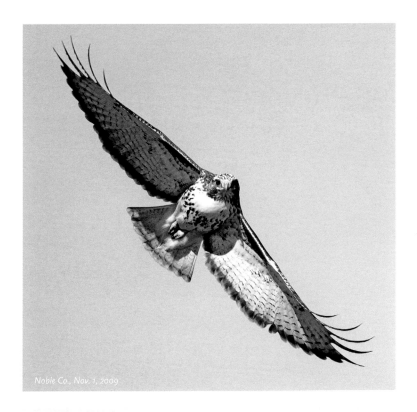

Some Harlan's Red-tailed Hawks are very light in color. These types are rare on the Oklahoma prairies in winter. Most of them have a faint rufous or dusky wash at the tips of their tail feathers.

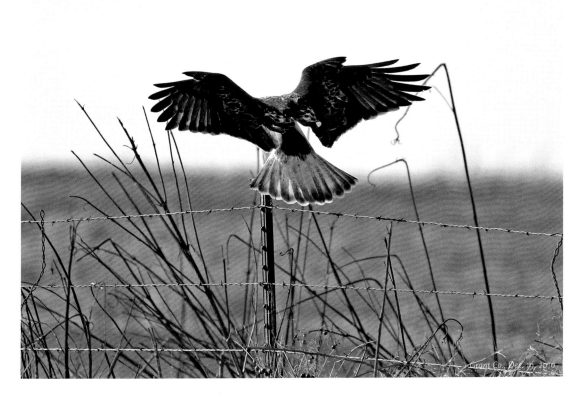

For Red-tailed Hawk aficionados, the most useful images for studying plumage are those that record multiple views of the same individual, like the light Harlan's Red-tailed Hawk shown here.

Kingfisher Co., Feb. 14, 2012

Payne Co., Nov. 5, 2010

Dark juvenile Harlan's Red-tailed Hawks, like those shown on this page, present challenging field identification problems. They strongly resemble juvenile Western Red-tailed Hawks, and their lanky appearance is reminiscent of another prairie hawk, the dark Rough-legged Hawk. Red-tailed Hawk field identification is challenging and rewarding but takes a lot of study; start with a good hawk field guide.

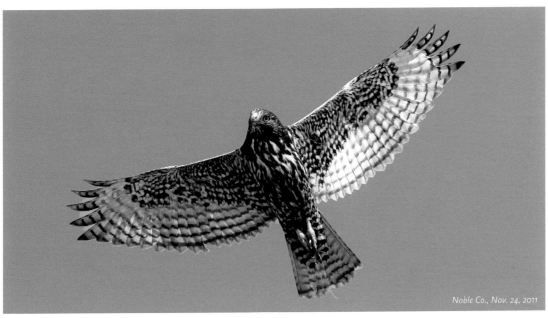

Noble Co., Nov. 24, 2011

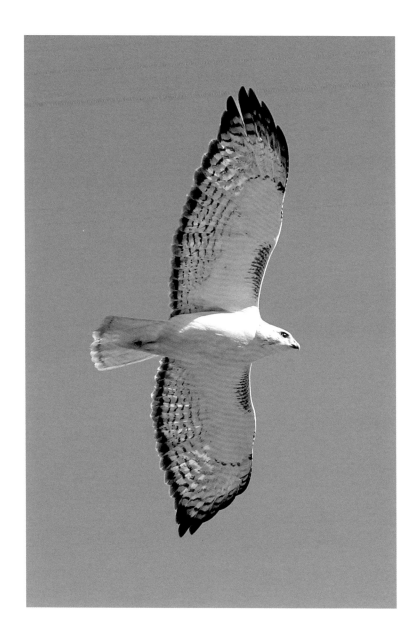

A very light Krider's
Red-tailed Hawk.
Kay Co., Feb. 25, 2012

Krider's Red-tailed Hawk

Buteo jamaicensis kriderii

One of the most attractive Red-tailed Hawks that find their way into Oklahoma during the winter is the Krider's Red-tailed Hawk. The exact breeding range, as well as practically everything else about these beautiful hawks, is very poorly understood. They nest sporadically in parts of Montana, North and South Dakota, Alberta, Saskatchewan, and Manitoba, and very limited areas of Wyoming, Colorado, Nebraska, and Minnesota. In those areas they are mixed in with typical Eastern Red-tailed Hawks, so some consider them just a very pale type of Eastern Red-tailed Hawk, with diluted coloration. Whatever they are, many are extremely beautiful.

The main distinguishing characteristic of Krider's Red-tailed Hawks is their overall whiteness, especially on their head and tail. Their young are also very whitish and quite distinctive. Krider's Red-tailed Hawks are one of the rarest types that occur in Oklahoma in winter, at least on the prairies of north-central Oklahoma. Because Eastern and Krider's Red-tailed Hawks intermingle on their breeding grounds, there are some hawks that show a blending of characteristics of both types. I have not had the opportunity to watch very many adults of these rare hawks. Most that I see are transients that I notice for a few days during migration, and then they disappear. However, one pair that was always together wintered at a very active oil field near Tonkawa for three consecutive years. They frequently sat on the cross arms of utility poles within one foot of each other and soared together when disturbed.

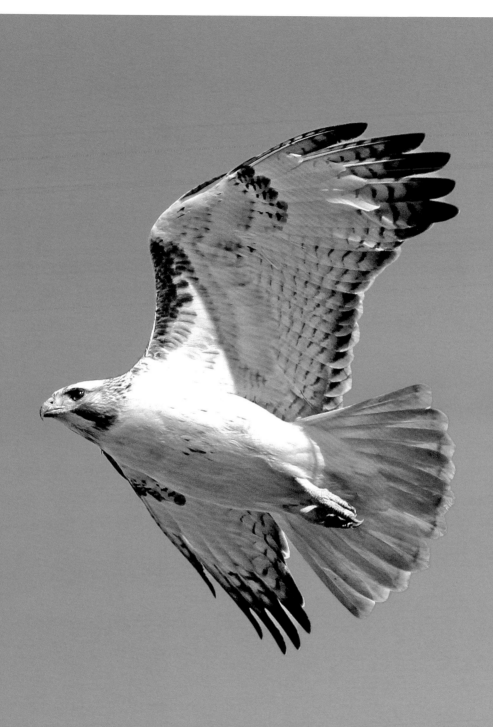

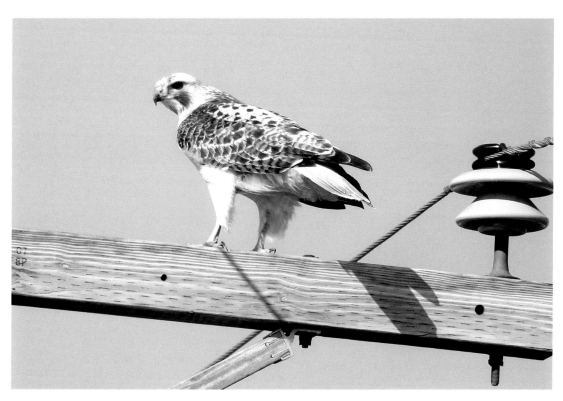

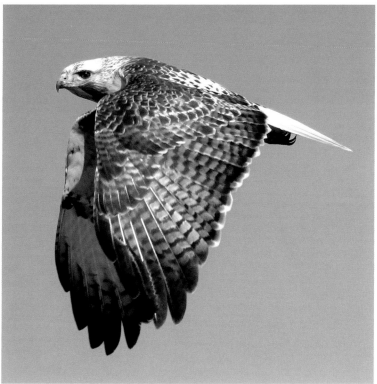

(This page and opposite) Krider's Red-tailed Hawks are rare in winter in north-central Oklahoma. Some are very white and conspicuous and can be spotted at a great distance. These images show the same bird from different views and with different lighting. This bird is presumed to be a male and was frequently seen perched with its larger Krider's mate. They wintered near Tonkawa, Oklahoma, for three years.

Kay Co., Mar. 2, 2010

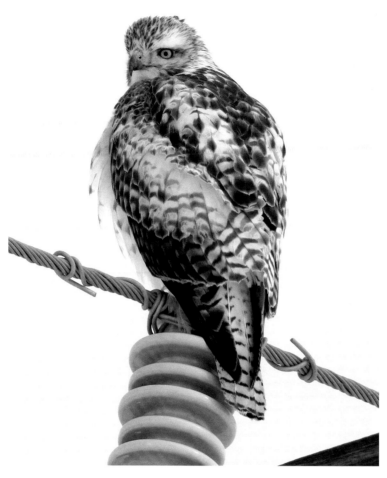

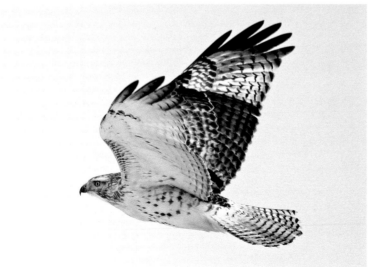

(This page and opposite, above) Juvenile Krider's Red-tailed Hawks are every bit as striking as adults, as these images show.
Noble Co., Jan. 30, 2010

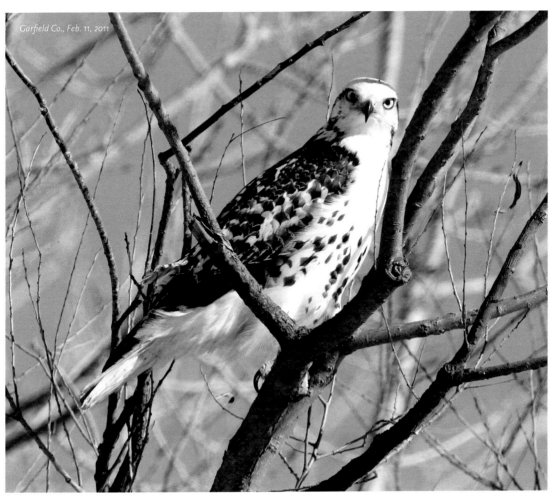

Garfield Co., Feb. 11, 2011

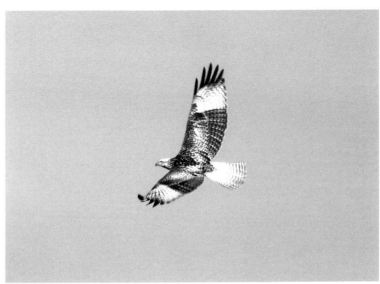

Nothing says "I'm not from around here" quite like the distinctive white wing panels and upper tail of a juvenile Krider's.

Noble Co., Jan. 18, 2010

White Red-tailed Hawks

One type of Red-tailed Hawk plumage that always draws a lot of attention is either completely snow white or has a patchwork of snow-white feathers mixed with normal-colored feathers. The genetic blueprint or DNA that oversees the making of Red-tailed Hawks of various races is fairly precise and over the centuries reliably "manufactures" hawks true to their type, albeit with the wide range of variation typical for this species. However, on very rare occasions something goes wrong with that blueprint and a mutation occurs, as happens with these nearly pure white or partially white Red-tailed Hawks.

These hawks are often referred to in books and in conversations among birders as albino or partially albino, but although everyone understands what is meant by these terms, it is genetically impossible to be a "partial" albino. Albinistic individuals do not have the genes that allow the production of the dark pigment melanin. Either you have it or you don't. Albinistic birds are extremely rare in nature and typically short lived. However, another type of mutation can occur that somehow interferes with the bird's ability to transfer or properly incorporate the melanin it does produce into its growing feathers. This condition is known as leucism and is probably what causes most of the white or partially white Red-tailed Hawks.

Most people consider these white or partially white Hawks to be special because they are so conspicuous and easily distinguished from the others. There are numerous accounts of them returning to the same winter territories for many years or residing in certain areas as breeders.

One white Red-tailed Hawk that became famous, or at least well known in central Oklahoma, resided near Norman. A local landowner named Marshall Pierson originally named it Norman, after his father. It was a resident bird that nested in the area, so later when it was observed to do most of the incubation during the nesting season, its gender was presumed to be female and it was renamed Norma. It was frequently photographed and observed, and as Dick Gunn, one of its admirers, states, "Everyone thought they owned it, calling it

A rare leucistic Harlan's Red-tailed Hawk near Marland, Oklahoma.

Noble Co., Dec. 4, 2011

White Red-tailed Hawks

my hawk." Unfortunately, in November 2011 Norma met a fate like that of so many of her kin and was found electrocuted beneath some power lines that she had frequented for many years. Her singed remains were given to the Sam Noble Oklahoma Museum of Natural History in Norman.

Over the years I have followed up on many reports of white Red-tailed Hawks, but although I have observed literally thousands of Red-tails in winter, I have seen very few white ones in the wild, attesting to the rarity of these special individuals.

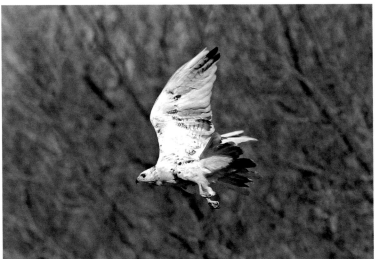

A leucistic Eastern Red-tailed Hawk. Some leucistic Red-tailed Hawks become well known locally and often make the newspaper.

Noble Co., Jan. 27, 2012

Hawks and Hawkscapes

A Gallery of Wintering Oklahoma Red-tailed Hawks

Faces no longer look from these empty windows; the yard is now claimed by a local resident adult Red-tailed Hawk.
Garfield Co., Dec. 28, 2010

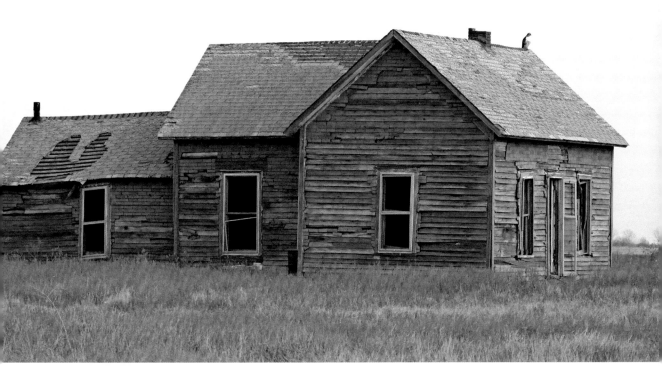

An adult Red-tailed Hawk in morning sun along the Salt Fork of the Arkansas River.

Grant Co., Dec. 2, 2010

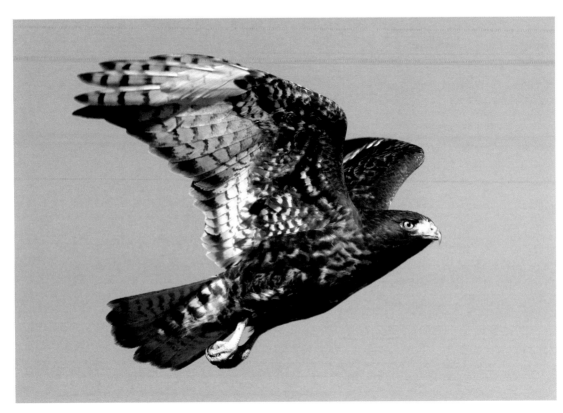

Many Red-tailed Hawks do not fit neatly into categories, like this beautiful, dark second year. Its plumage shows traits of both Western and Harlan's Red-tailed Hawks. Red-tailed Hawks like this are referred to as intergrades. A guess about where a Red-tailed Hawk on its wintering grounds was born based on its plumage is always, in the end, just a guess, even by experts.

Kay Co., Nov. 30, 2011

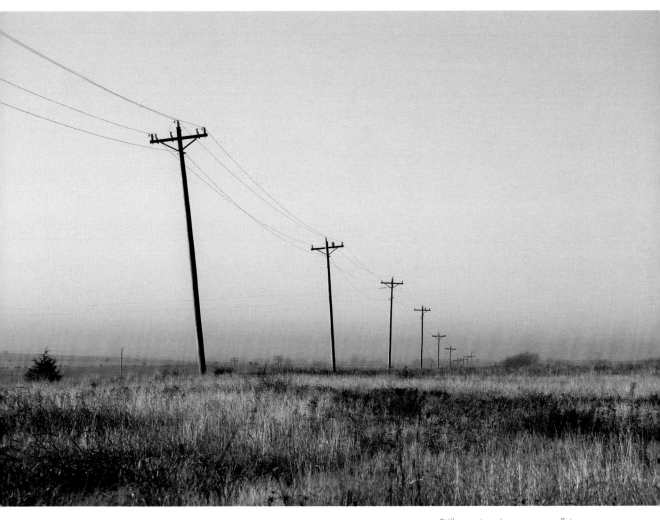

Still morning air means poor flying conditions, and Red-tailed Hawks often stay grounded until later in the day when thermals begin to form.
Noble Co., Nov. 23, 2011

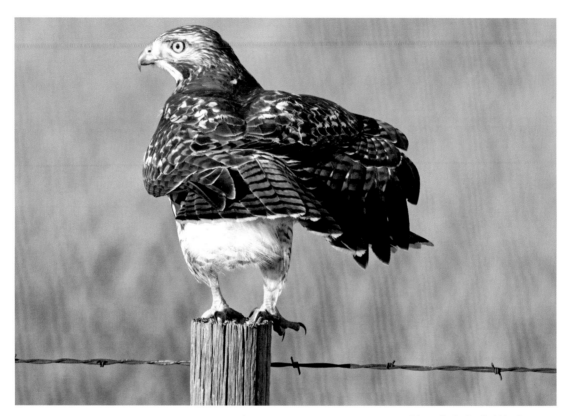

A juvenile Red-tailed Hawk stretching wing and tail on one side, a common avian behavior.
Noble Co., Nov. 25, 2009

Red-tailed Hawks thrive in areas where land uses such as agriculture and grazing are mixed with remnant patches of prairie and woods.

Noble Co., Feb. 5, 2011

A resident pair of Red-tailed Hawks perched on the same fence post. Remnants of their nest from the previous season can be seen in the upper branches of the elm on the left.

Noble Co., Nov. 27, 2009

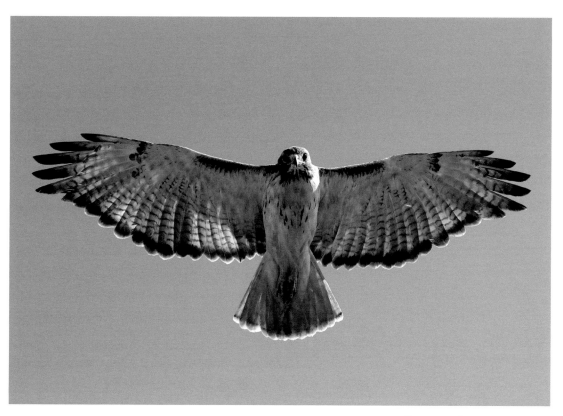

The near-perfect symmetry of an adult Red-tailed Hawk directly overhead.
Noble Co., Oct. 17, 2013

A barn and its hawk.

county unknown, Nov. 23, 2011

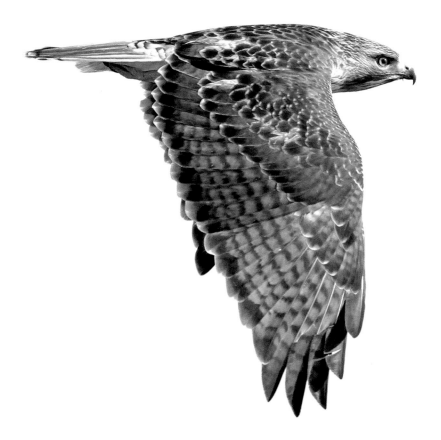

Modern lenses and digital cameras are great tools for the study of plumage in Red-tailed Hawks and are able to capture amazing detail.
Kay Co., Dec. 28, 2010

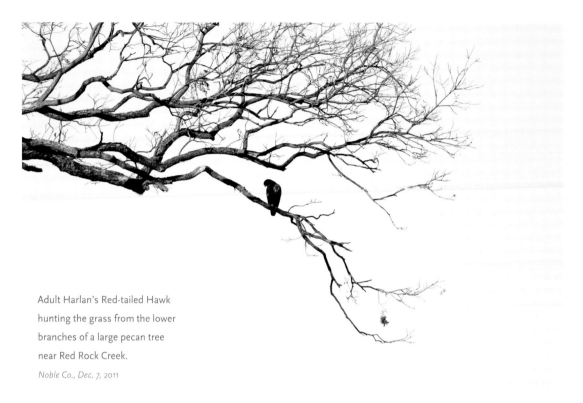

Adult Harlan's Red-tailed Hawk hunting the grass from the lower branches of a large pecan tree near Red Rock Creek.

Noble Co., Dec. 7, 2011

This hawk is hunting a patch of nonnative giant reed that has escaped from a nearby yard.

Noble Co., Jan. 16, 2011

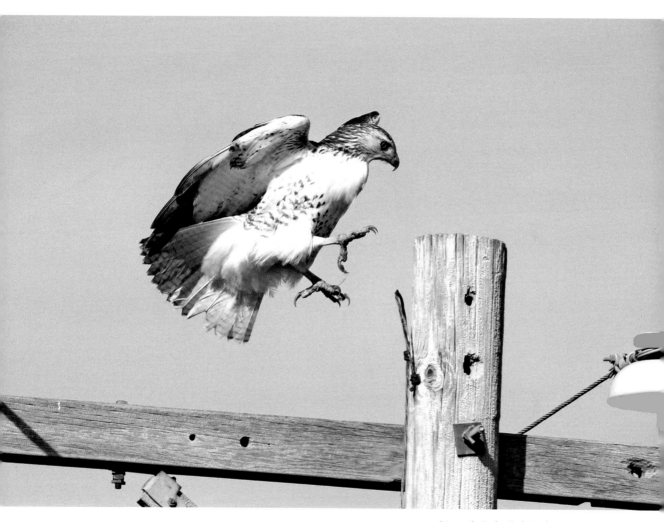

A juvenile Red-tailed Hawk stalling out for a perfect two-point landing.
Grant Co., Nov. 18, 2010

Three wind machines; a pair of adult Red-tailed Hawks.

Grant Co., Dec. 2, 2010

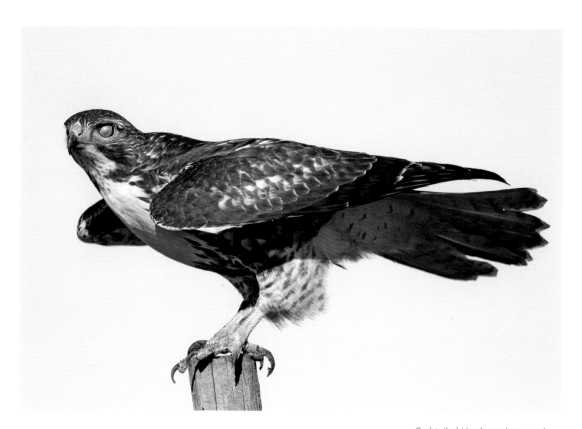

Red-tailed Hawks and most other birds have a well-developed third eyelid that lubricates, cleans, and protects the cornea. This juvenile hawk has just flushed from a muddy bar ditch.
Noble Co., Oct. 31, 2009

It is not uncommon in winter to see several Red-tailed Hawks hunting this eighty-acre patch of dense switchgrass on a private hunting preserve.

Noble Co., Dec. 23, 2011

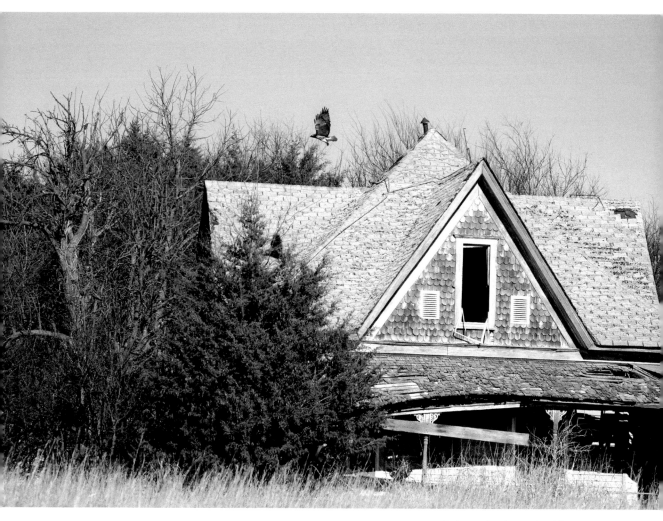

Eastern red cedars and prairie grasses reclaim another old home; a regular hangout for this local adult Red-tailed Hawk.
Grant Co., Dec. 12, 2010

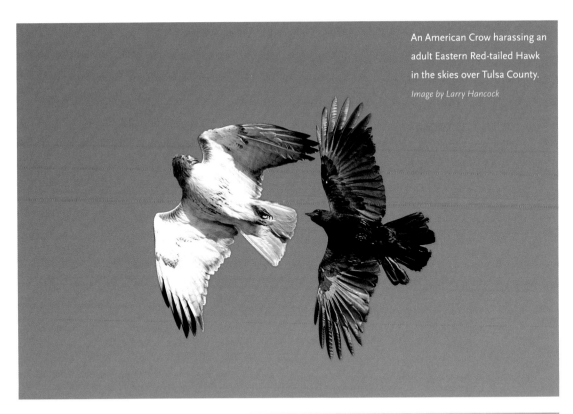

An American Crow harassing an adult Eastern Red-tailed Hawk in the skies over Tulsa County.
Image by Larry Hancock

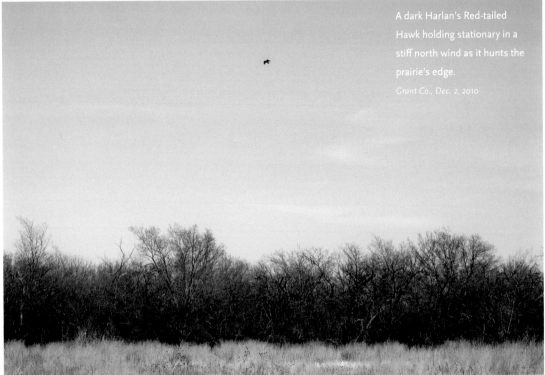

A dark Harlan's Red-tailed Hawk holding stationary in a stiff north wind as it hunts the prairie's edge.
Grant Co., Dec. 2, 2010

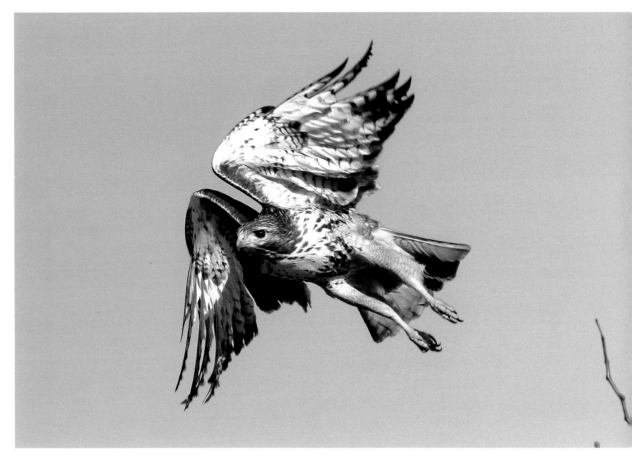

The wrist joints of this hawk almost meet on the upstroke of its wings. The power for forward thrust is created on the downstroke.

Noble Co., Dec. 11, 2012

Large eastern red cedar trees, most over a century old, usually mark the location of an old homestead.

Garfield Co., Jan. 28, 2011

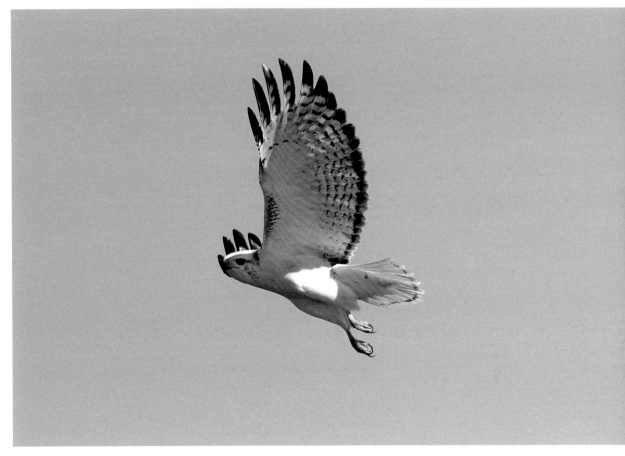

An adult Krider's Red-tailed Hawk. There is something special about this very white and very rare type of Red-tail.
Grant Co., Feb. 26, 2012

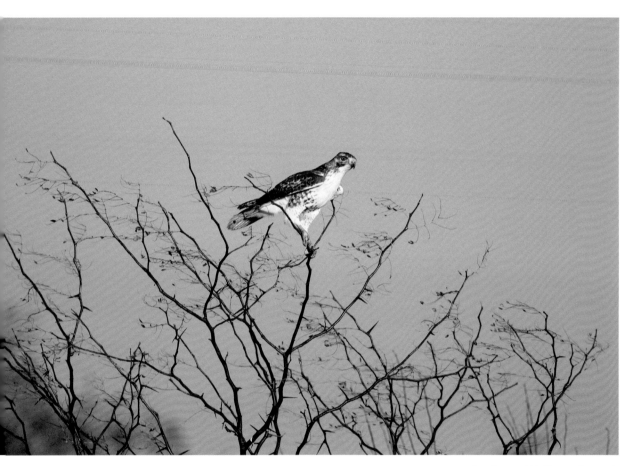

A well-armed bird in a well-armed honey locust tree in late afternoon light.

Payne Co., Nov. 6, 2009

Whether by bullet or buckshot, tooth or talon, disease or starvation, for many Red-tailed Hawks it's a one-way trip to the southern plains.

Grant Co., Dec. 12, 2010

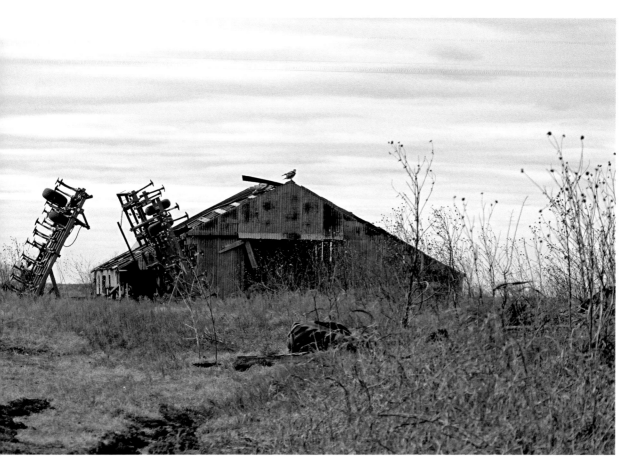

Juvenile Red-tailed Hawk under a winter sky.

Noble Co., Feb. 16, 2010

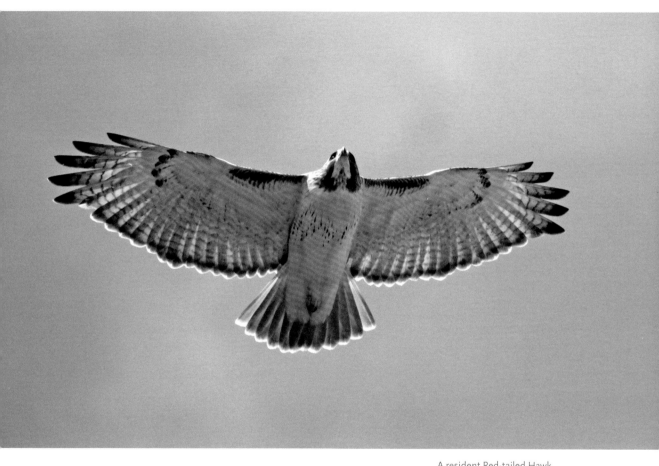

A resident Red-tailed Hawk showing the clear, unbanded tail typical of most, but not all, of our residents.
Noble Co., Feb. 15, 2009

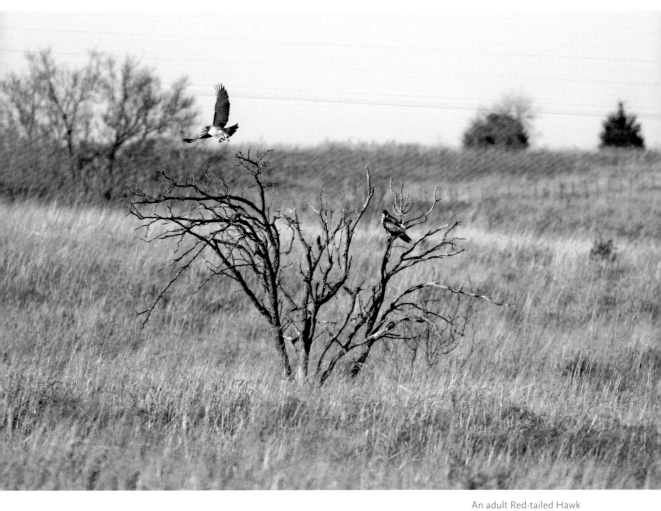

An adult Red-tailed Hawk flies from a snag with a small unconsumed portion of a rodent. The juvenile perched nearby was hoping for some leftovers. Normally, adults do not tolerate juveniles.

Kay Co., Dec. 10, 2009

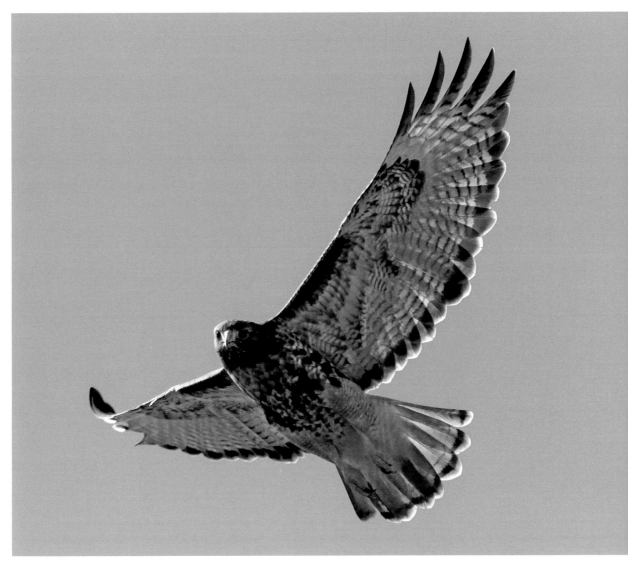

A beautiful, heavily marked Eastern Red-tailed Hawk.
Noble Co., Oct. 27, 2009

A resident adult hawk near its nest.

Noble Co., Feb. 24, 2010

A good hawk road.

Garfield Co., Feb. 11, 2011

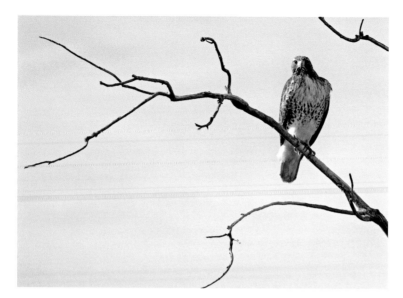

The lyrical lines of this prairie tree's branches were drawn by the Great Plains winds and perfectly complement the noble pose struck by this adult Red-tailed Hawk.
Osage Co., Jan. 15, 2011

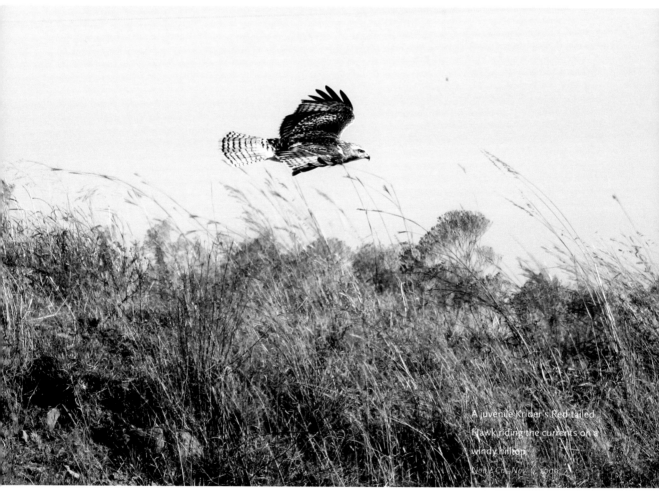

A juvenile Krider's Red-tailed Hawk riding the currents on a windy hilltop.
Noble Co., Nov. 6, 2009

134 *Winter's Hawk*

This wide-reaching prairie elm has been the nest site of both Red-tailed Hawks and American Crows in recent years. Near-perfect specimens like this are rare on the open prairies where wind, ice, and violent spring storms leave most with many broken limbs (see page 143 for comparison).
Noble Co., Dec. 4, 2009

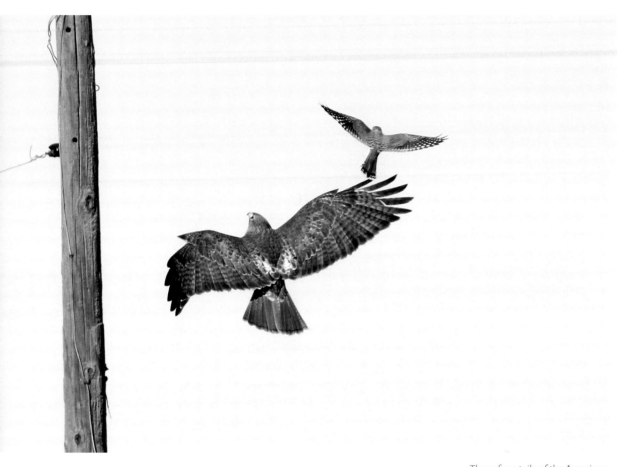

The rufous tails of the American Kestrel and Red-tailed Hawk match the rusty roads of north-central Oklahoma.

Grant Co., Nov. 23, 2011

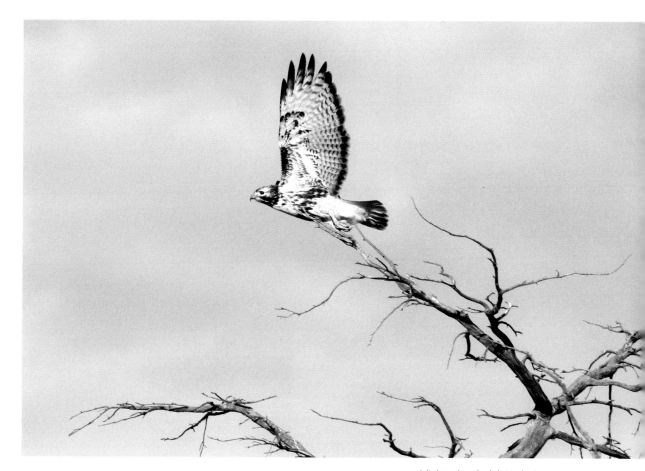

A light-colored adult Harlan's Red-tailed Hawk floats from its windy perch. Note the dark, well-defined trailing margin of the wings, characteristic of all adult Red-tailed Hawks.
Garfield Co., Dec. 31, 2010

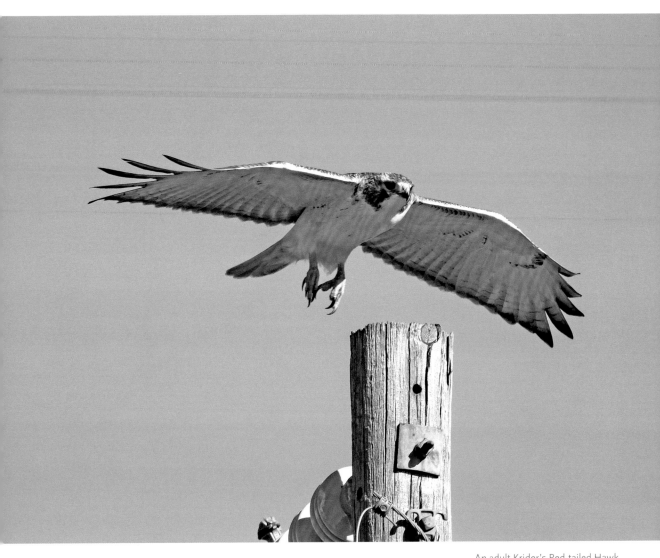

An adult Krider's Red-tailed Hawk shows impressive flight control as it gracefully lands on this pole against a stiff wind.
Kay Co., Nov. 27, 2009

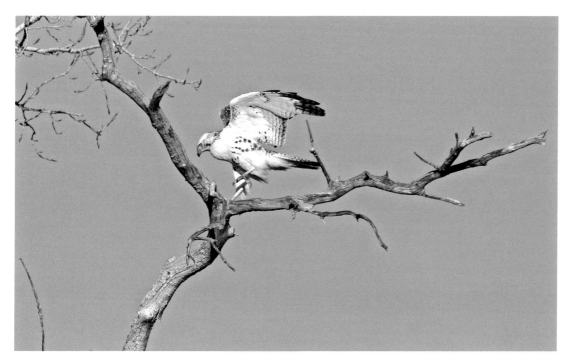

This juvenile Krider's Red-tailed Hawk stands out brightly against a blue sky.

Garfield Co., Dec. 10, 2012

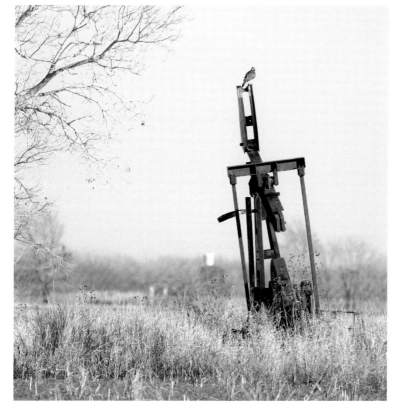

Adult Red-tailed Hawk hunting from abandoned oil field equipment.

Kay Co., Dec. 8, 2011

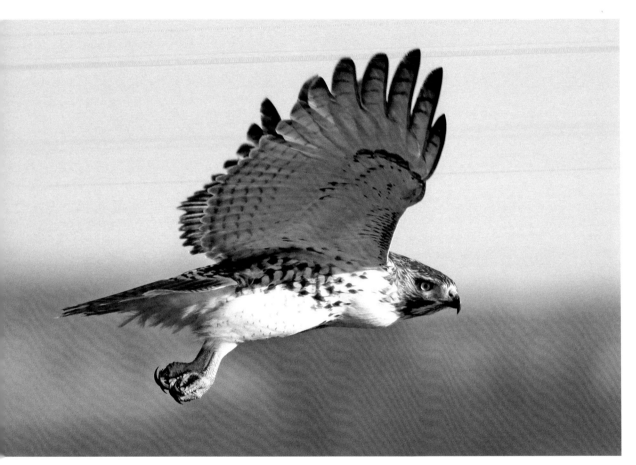

The full crop and perfect set of feathers are good signs for this young hawk as it heads into its first winter.

Noble Co., Nov. 22, 2009

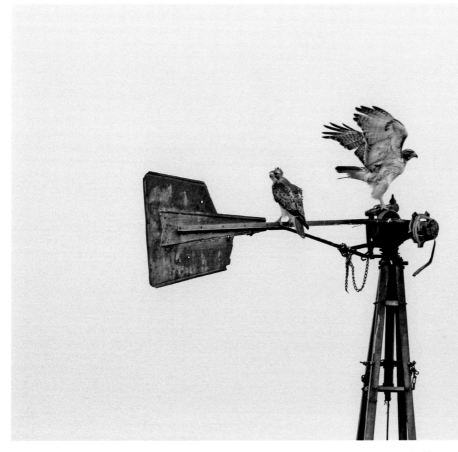

Resident pair of Red-tailed Hawks perched together near their nest

Garfield Co., Jan. 22, 2011

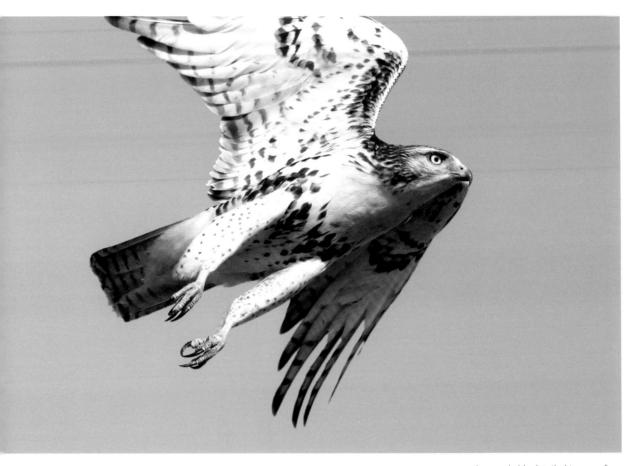

A remarkably detailed image of a juvenile Red-tailed Hawk. The soft skin around a bird's nostrils is called the cere and in juvenile Red-tails it is often bluish green. Adults typically have a yellowish cere.
Noble Co., Feb. 2, 2009

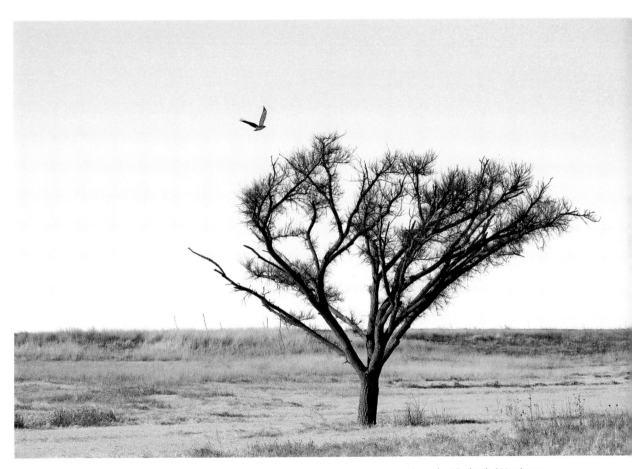

A resident Red-tailed Hawk near its nest in winter. Many prairie elms, like this specimen, are severely pruned by wind and ice.
Grant Co., Dec. 12, 2010

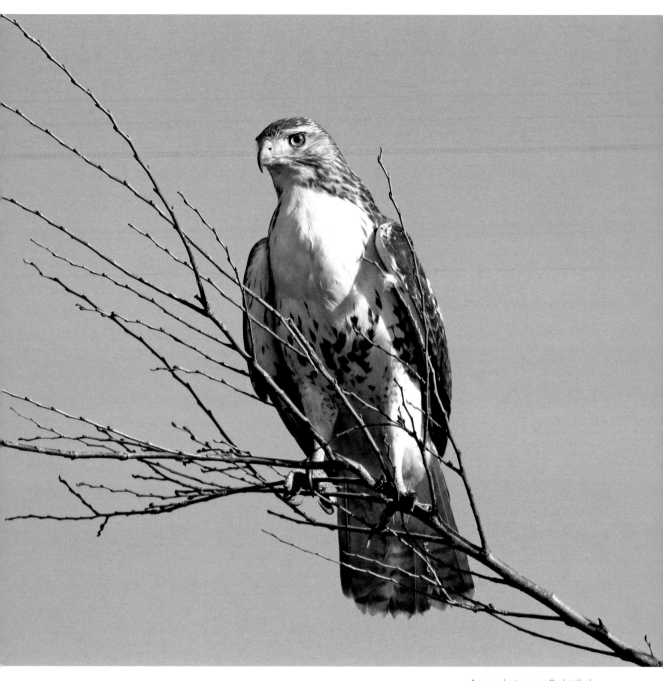

A very alert young Red-tailed Hawk.

Noble Co., Nov. 18, 2009

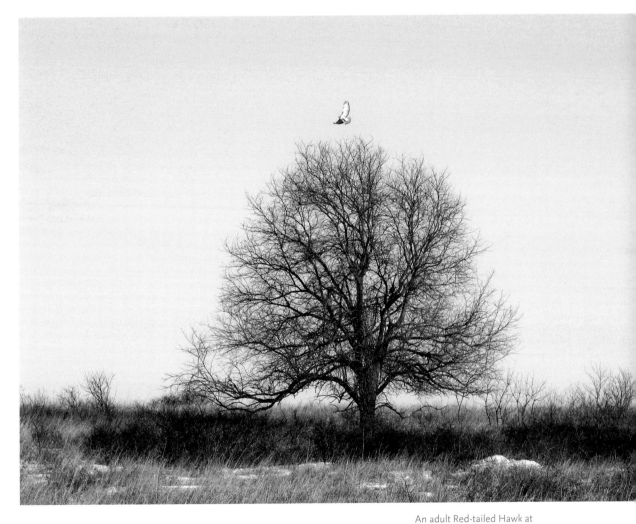

An adult Red-tailed Hawk at its habitual hunting perch near Sooner Reservoir. This elm is situated among a thick stand of Chickasaw plums and sumac—ideal cotton rat habitat.

Noble Co., Dec. 26, 2009

The thick clumps of switchgrass, like other dominant prairie grasses, are long lived and have deep roots to seek water during the frequent droughts that characterize the southern Great Plains.
Grant Co., Dec. 18, 2010

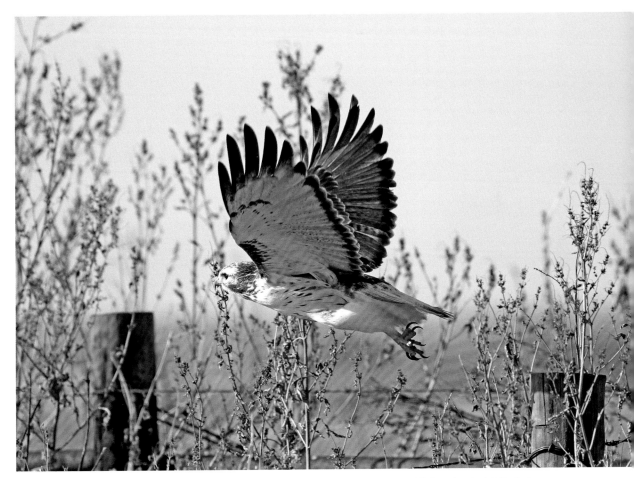

A light-colored adult Harlan's Red-tailed Hawk. Typically, only adult Red-tailed Hawks have bright yellow feet.
Garfield Co., Dec. 19, 2010

Red-tailed Hawk country along a sweeping bend of the Salt Fork of the Arkansas River.
Grant Co., Nov. 23, 2011

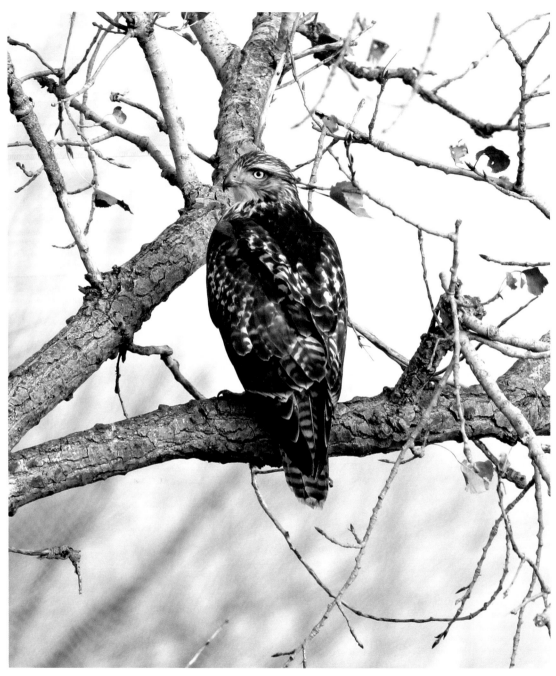

Juvenile Red-tailed Hawk perched in a cottonwood tree along the road.
Noble Co., Dec. 9, 2011

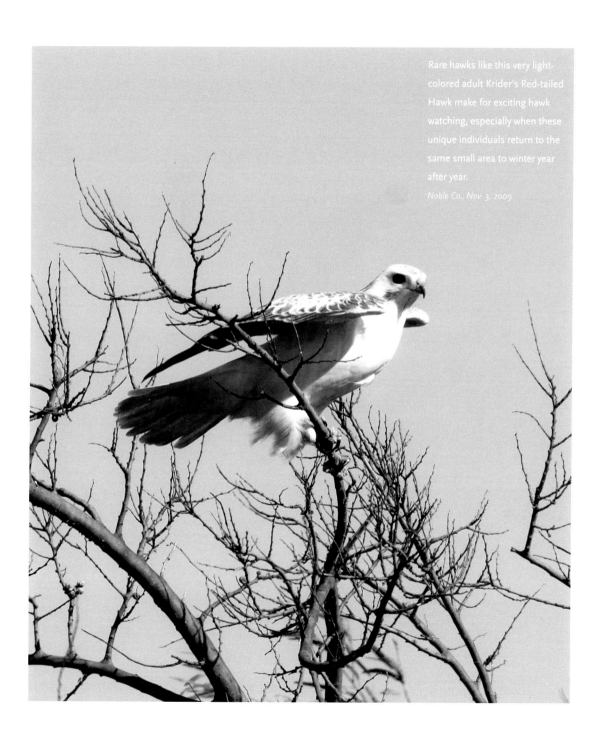

Rare hawks like this very light-colored adult Krider's Red-tailed Hawk make for exciting hawk watching, especially when these unique individuals return to the same small area to winter year after year.

Noble Co., Nov. 3, 2009

(This page and opposite) **This dramatic interaction between a young Red-tailed Hawk and an adult Bald Eagle vividly illustrates just how dangerous the skies can be, especially for inexperienced hawks. Red-tailed Hawks are lighter on the wing and more maneuverable than eagles and can usually avoid injury. But eagles are deceptively fast and are known to flip upside down in a split second; with their surprisingly long reach, they can snatch hawks right out of the air. Note the impressive size difference between these two species.**
Noble Co., Jan. 9, 2015

Grant County panorama.
Dec. 17, 2011

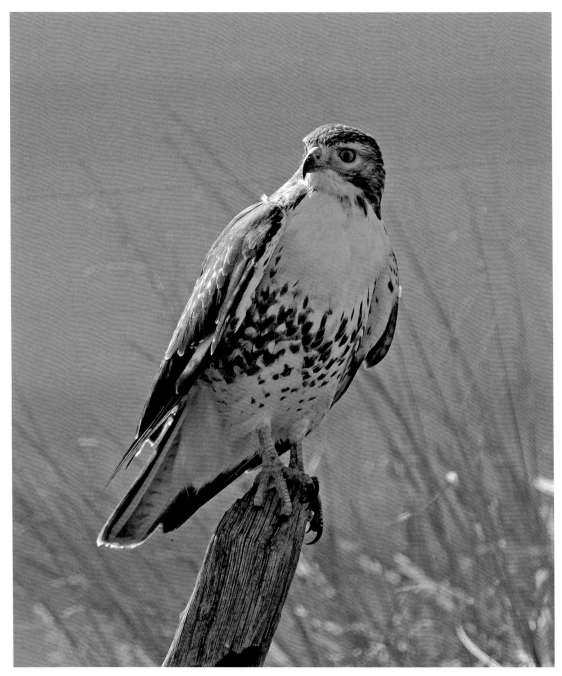

The green of a winter wheat field and dried roadside grasses form a pleasing backdrop for this near studio-perfect portrait of a young Red-tailed Hawk.

Grant Co., Oct. 28, 2011

Winter Hawks on a Changing Prairie

Red-tailed Hawks have been on the southern plains for millennia. By the end of the last Ice Age more than one hundred centuries ago, possibly earlier, they were here. From mammoths and saber-toothed cats to Black Angus cattle, winter wheat, and interstate highways; from Clovis encampments to modern metropolises; from arrows to bullets; from land rush to oil boom—

Signs of the times? Will the entire prairie landscape at some point in the future be studded with behemoth wind generators like the one shown here? Will our incessant prairie winds be the answer to our country's voracious demands for energy? What sad days they will be when the pole tops are vacant.

Grant Co., Nov. 2, 2013

the Red-tailed Hawk has survived dramatic changes, a testament to the remarkable adaptability of this bird. But new challenges are on the horizon for the Red-tailed Hawks that winter on Oklahoma's prairies. During my short perspective of only a few decades, some dramatic changes have become apparent. Energy exploration, changing agricultural practices, prolonged sequential droughts, and the rapid urbanization of many parts of rural Oklahoma are fragmenting the native grasslands into smaller and smaller pieces. If the Northern Bobwhite and the Greater Prairie Chicken have taught us anything, it is not to take things for granted. The "phenomenon" of being able to go out on a winter afternoon to the prairies of Oklahoma and see hundreds of Red-tailed Hawks depends, in the long run, on many factors. Perhaps the most important of these is a thriving rodent population, which depends on grassy roadsides and prairies. A warming climate and the accompanying severe droughts might also significantly diminish the numbers of northern Red-tailed Hawks that migrate down the plains each

Red-tailed Hawk country in Noble County in 2014. All prairie lovers have probably stood looking out at their favorite vista and wished they could have enjoyed the same view during a more pristine time. What we see today are small remnants of tallgrass prairie that have survived the plow and other changes both ecological and human made. Will these grasslands where hawks have wintered for centuries survive in the face of rapid urbanization, changing land use, and a resurgent energy boom that is historic in its sweep? Perhaps someday a future Red-tailed Hawk student or ardent grassland lover will return to this exact location and record the changes time has made. Location: Ute Bluff Road looking due east toward Sooner Power Station in Noble County: 36°26'57.84" N, 97°08'18.26" W.
Mar. 9, 2014, 2:37 P.M.

year. They could easily start wintering farther north. Illegal shooting is also still a major problem.

The Red-tailed Hawk is a valuable and extremely beneficial part of Oklahoma's wildlife heritage. It would be a shame if future generations were denied the experience of enjoying their beauty. A Red-tailed Hawk that arrives on the prairies of Oklahoma in early October and departs in March spends a full half year here on its winter territory. When you add some time, say two weeks for migrating down and two weeks for migrating back, that means many of these birds spend more time on their wintering territories than on their nesting territories. This underscores just how essential the grasslands and the rodent populations of the southern Great Plains are for the long-term survival of these birds. My friend Fritz Knopf has a way with words and the perspective of many years of landscape ecology and ornithological studies. He condensed this idea to this elegant sentence: "These prairies are home to a winter visitor whose annual return tracks its own health."

With infinitely confident little variations of his finger-ends
He soothes the erratic winds

—Leslie Norris, "Buzzard"

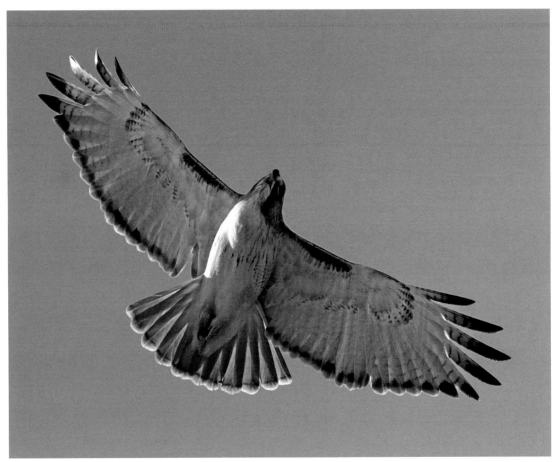

Garfield Co., Dec. 19, 2010

Selected References

There is a lot of information available for those who would like to learn more about Red-tailed Hawks. Here are some suggestions to get you started.

Nontechnical

Austing, G. R. 1964. *The World of the Red-tailed Hawk*. Philadelphia: J. B. Lippincott.

Baumgartner, F. M., and A. M. Baumgartner. 1992. *Oklahoma Bird Life*. Norman: University of Oklahoma Press.

Preston, C. R. 2000. *Red-tailed Hawk*. Mechanicsburg, PA: Stackpole Books.

Sutton, G. M. 1986. *Birds Worth Watching*. Norman: University of Oklahoma Press.

Technical

Lish, J. W. 2007. "Comments on the Distribution of the Fuertes Red-tailed Hawk on the Southern Great Plains." *Journal of Raptor Research* 41 (4): 325–27.

Lish, J. W., and L. J. Burge. 1995. "Population Characteristics of Red-tailed Hawks Wintering on the Tallgrass Prairies in Oklahoma." *Southwestern Naturalist* 40 (2): 174–79.

Lowe, C. 1978. "Certain Life History Aspects of the Red-tailed Hawk, Central Oklahoma and Interior Alaska." Master's thesis, University of Alaska Fairbanks.

Palmer, R. S. 1988. "Red-tailed Hawk." In *Handbook of North American Birds*, vol. 5, part 2, 96–134. New Haven, CT: Yale University Press.

Preston, C. R., and R. D. Beane. 2009. "Red-tailed Hawk (*Buteo jamaicensis*)." *The Birds of North America Online*, edited by A. Poole. Ithaca, NY: Cornell Lab of Ornithology. http://bna.birds.cornell.edu/bna/species/052. doi:10.2173/bna.52.

Sutton, G. M. 1967. *Oklahoma Birds*. Norman: University of Oklahoma Press.

Index

Page numbers in **bold** indicate photographs.

abieticola, 76
adult hawks: interaction with juveniles, 35–37; nostrils, **141**; topside view of, **62**; underside view of, **60**; wing markings, 62–63
aerial combat, 29, 31, **32,** 33; with Bald Eagle, 45–46
age identification, 59–63
air deflection, **48**
albinism, 102
American Crows, 49, **122**
American Indians, xi
American Kestrels, 18, **136**
Arctic storms, 4, 10, **10,** 12
Arkansas, 40
Arkansas River, 45, **107, 148–49**
Audubon, John James, 88
automobile traffic, 26
aves, 3

Bald Eagles, 45, 91, **152–53**
beaver, 54
Bedrosian, Bryan, 40
beneficial impact of hawks, 159; for bobwhites, 54; rodent predation, 23; snake predation, 33
biological classification, 55
bird migration, 3–4. *See also* migration
Birds Worth Watching (Sutton), 68
bison herds, xi
Black-tailed jackrabbits, 54
Black Warrior, 88
Bluejacket, Okla., 23
Blue Jay, 52
bobwhites, 23, 53–54, 158
body and wing structure: crop, **30, 140**; digestion process, **30**; feet, 91, **92, 147**; in hovering, **12**; of juveniles, 62–63; symmetry of, **113**; talons, 18, **20**; topside view of, **62**; underside view of, **60–61**; in weathering high winds, **11,** 12–13; wrist joints, **123**

breast streaking, 67, **68, 88**
breeding cycle, 71–72
breeding pairs. *See* mated pairs
breeding range: for Eastern Red-tailed Hawk, 65; for Fuertes Red-tailed Hawk, 65; for Krider's Red-tailed hawk, 97
Brewster County, Tex., 67
Buteo jamaicensis, xii
Buteo jamaicensis borealis, 65
Buteo jamaicensis fuertesi, 65
Buteo jamaicensis kriderii, 97
Buteo lagopus, 6
"Buzzard" (Norris), 160

caloric requirements, 31
cere, **141**
Chickasaw plums, **145**
chicken hawks, xiii–xiv
climate change, 158–59
close-to-the-action hunting strategy, 27–28
coloration, xv; bellies, **4**; foot, **147**; morphs, 79; nostrils, **141**; variation in, 7, **8**; white Red-tailed Hawks, 102–104, **103, 104**. *See also* plumage
color phases, 79, **80–83**
competition. *See* hawk competition
Cooper's Hawk, 54, 90
cotton rat irruption, 22–23
cotton rat nest, **19**
cotton rat runways, 28
cotton rats, **18, 19,** 91; common name for, 22; feeding habits, 23; habitat, **145**; hawks' hunting strategies and, 27–28; life-cycle, 22–23; population density, 23; in prairie ecosystem, 22; as primary food source, 17–18; remains in raptor pellets, 21–22; storms' impact on, **10**; vulnerability to raptors, 18
cottonwood trees, **13, 150**
courtship displays, 8, 71
Craig County population density, 5
crop, **30, 140**

163

Cross Timbers, 6
crows, 49, **122**

dark-phase morphs, **83**
digestion process, **30**
diving attacks, 27–28
drive-by shootings, 40, 43, **43**
ducks, **17**

eagles, 45–46, 54, 91, **152–53**
eastern red cedar tree, **124**
Eastern Red-tailed Hawk, **73, 122, 131**; breast streaking in identification, 67; breeding range, 65; migration and, 74, 76; plumage, 67, **75–77**
Edmond, Okla., 39
educational programs, xiv, 46
electric fences, 43, 45
electrocution, **43, 44**
European Starlings, 52
evasive behaviors, toward humans, 26–27
eye coloration, 63
eyelid, third, **119**
eyesight, 8, **47**

falcons, 45
farms, abandoned, 20–21, **105, 114, 121,** 128
feather damage, 40, 43; as health indicator, 37
feathers. *See* plumage
feeding habits. *See* prey and feeding habits
flight: diving attacks, 27–28; hovering, 12–13; landing, **117, 138**; riding thermals, **47,** 49; soaring, 47–49; wind deflection and, **48,** 49; wrist joints in, **123**. *See also* hunting strategies
flight speed, 49
foot coloration, **147**
foot deformities, 40, **42, 64, 92**
foot grip, in killing prey, 18, **20**
foot size, 91
Fuertes, James Audubon, 67
Fuertes Red-tailed Hawk, **68**; breeding range, 65; plumage, 67

Garfield County sightings, **ii–iii,** 7, **25,** 30, **38,** 39, **41,** 81, 88–89, **89,** 90, **101, 105, 124, 133, 137, 141, 147, 160**
Golden Eagles, 45–46, 54
Grant County sightings, **vi, xi,** 6, **27,** 34, **50,** 75, 82, 86–**89, 93, 107, 118, 121, 122, 125, 127, 136, 143, 146, 154**
grass trailing, **19,** 31, **32**
Greater Prairie Chickens, 54, 158
Great Plains, xiii, xv, **146**
Gunn, Dick, 102, 104

habitat: abandoned farms, 20–21, **105, 114, 121, 128;** of bobwhites, 53; of cotton rats, 23, **145;** humans in shaping, 5–6, **111;** modern changes to, 157–59; parklands, 76

Hammerstein, Oscar, xi
Harlan, Richard, 88
Harlan's Red-Tail Hawk, **84, 87, 89, 116, 122, 137;** classification of, 85–86; coloration, **93, 95, 137;** feet, 91, **92, 147;** hunting Red-winged Blackbirds, 88–91; nesting territories, 85; origin of name, 88; territoriality, 91
harriers, 30–31
hawk competition: adult attacks on juveniles, 35–37; aerial combat, 31, **32,** 33; Harlan's Red-tailed Hawks and, 91; local versus migratory populations and, 68, 70; theft of prey, 29, 39, **40**
hawk counting technique, 4–5
hawk crop, **30, 140**
hawk pellets, 21–22
"hawkscapes," xv
hawk watching: best days for, 13; on roadsides and railroad track rights-of-way, 23–26. *See also* **sightings by county**
hawk watching landscapes, xiii, **24**–25, **148–49, 158–59**
health indicators, 37. *See also* injured birds
hispid cotton rat. *See* cotton rats
honey locust tree, **126**
hovering technique, 12–13
Hughes, Wallace, 23
humans and human factors: automobile traffic, 26; in bobwhite decline, 53–54; Harlan's Red-tailed Hawks response to, 86; in hawk injuries, 40, 43; in hawk soaring, 49; hawks' response to, 26–27, **50,** 51–52; in hunting perch creation, 23–26; juvenile hawks and, 37; as predators, xiii–xiv; in shaping habitat, 5–6, 157–59
hunger calls, 39
hunting strategies: cotton rats and, 27–28; diving attacks, 27–28; perch preferences and, 7; sit-and-watch method, 5–6; on windy days, 12–13

individual identification, 7, **8,** 58; cameras' role in, **115;** local versus migratory populations, 65; plumage in, **94, 95;** race characteristics and, 67–68
injured birds: electrocution and, **44;** feather damage, 40, 43; foot deformities, 40, **42, 64, 92;** health indicators, 37; rodent bites, 18; as scavengers, 39–40
intergrades, 55
interstate highways, 26

jackrabbits, 54
juvenile hawks, **110, 128, 144, 150;** adult attacks on, 35–37, **130;** adult chasing by, 39; Harlan's Red-tailed Hawk, **95;** Krider's Red-tailed Hawk, **100–101, 134, 139;** nostrils, **141;** plumage, 37, **38, 59;** in second year, 63; starvation and, 37, 39; survival challenges, 35–40; tail markings, **59;** third eyelid, **119;** threats to, **34,** 35–36; underside view of, **61;** wing shape, 62–63

Kansas Turnpike, xii–xiii

Kay County sightings, **11, 15, 19, 28,** 45, **76, 82, 98, 99, 115, 130, 138, 139**
Kenton County sightings, 79
kingbird family, **70**
Kingfisher County sightings, **30, 47, 64, 69**
Knopf, Fritz, 159
Krider's Red-tailed Hawk, 90, **96, 98, 99, 125, 138, 151**; breeding range, 97; juveniles, **100–101, 134, 139**
Kumlein, Ludovic, 6

landing, **117, 138**
legal protection: electrocution and, **43**; legislation protecting raptors, 23
leucism, 102, **103, 104**
light-phase morphs, **81**
Lish, John, 23, 35
Logan County sightings, **68**
Lord of the Rings (film), 51
Lowe, Craig, 36

mated pairs, **141**; breeding cycle and, 71–72; courtship displays, 8, 71; identification of, 7–8, **9**; Krider's Red-tailed Hawk, 97, **99**
Meadowlark, **29**
Melville, Herman, 49
Merlins, 90
migration, xiii, 3; Arctic storms and, 10, 12; climate change and, 158–59; of Harlan's Red-tailed Hawk, 85; local population and, 65, 68–72, 74, 76; of mated pairs, 7–8; prey availability in, 3–4
mimicry, 52
Missouri, Kansas and Texas Railway, 6
Missouri Department of Conservation, 54
molting, 63, **64**
morphs, in coloration, 79
Muir, John, 54
Muskogee Turnpike, 26

nest building, 71–72
nesting territories: of Harlan Red-tailed Hawk, 85; hawks' preference for, 3; spring departure for, 14
Noble County sightings, **i, viii,** 1–3, 8–10, 12, 13, 16, 17, 19, 21, 28, 32, 36, 40, 40–43, 46, 54, 59, 62, 66, 71, 73, 76, 80, 81, 83, 88, 91, 92, 93, 95, 100, 101, 103, 104, 109–12, 116, 118, 120, 123, 128, 129, 131, 132, 134, 135, 140, 143, 144, 145, 150–53
Norma (hawk), 102, 104
Norman, Okla., 102
Norris, Leslie, 160
Northern Bobwhites, 23, 53–54, 158
Northern Harrier, 30–31
Northern Red-tailed Hawks, 76, **77**
Northern Shoveler duck, **17**
Norway rats, 20

Oklahoma: Red-tailed Hawks population density in, 5. *See also* **specific counties**
Oklahoma Birds (Sutton), 67, 85
Oklahoma City, Okla., 36
Oklahoma counties, **5**. *See also* **specific counties**
Oklahoma Department of Wildlife Conservation, 23
Oklahoma landscape, 49
Oklahoma state song, xi
Oklahoma topography, **48**
"On the Edge: A Guide to Managing Habitat for Bobwhite Quail" (Missouri Department of Conservation), 54
opossum, 37, 39
Osage County sightings, **11, 80, 134**
Ottawa County sightings, xiv, 35, 54
owl pellets, 22

pack rats, 20
Pawnee County sightings, **xi, 16, 75, 83**
Payne County sightings, **19, 75, 95, 126**
pellets, 21–22
perch preferences, 5–6, **7**; manmade, 23–26; telegraph poles, **71**; utility poles, 43, **44,** 45
peregrine falcons, 45
personality traits, 51–52
phases, in coloration, 79
pheasants, 30–31
Pierson, Marshall, 102
plumage: in age identification, 59–63; breast streaking, 67, **68, 88**; color variations, 7, **8,** 55–58, **56–57**; Eastern Red-Tailed Hawks, **75–77**; Eastern versus Fuertes Red-tailed Hawk, 67, **74**; feather damage, 40, 43; Harlan's Red-tailed Hawk, 85–86; indeterminate categories in, **108**; of juveniles, 37, **38,** 59; Krider's Red-tailed Hawk, 97; local versus migratory populations, 65; morph color ranges in, 79; study of individual, **94**; underside of adults, **60**; white, 102; winter, 37. *See also* coloration
polymorphism, 58
population density, xii, 4–5; Arctic storms as factor in, 10, 12; of cotton rats, 23; prey as factor in, 8
prairie elm tree, **135, 143, 145**
prairie fires, **xv,** 5–6
prairie grasses, **146**
predators and predation: of bobwhites, 54; eagles, 45–46, **152–53**; humans, xiii–xiv; snakes, 33; survival challenges for, 35–36
prey and feeding habits: caloric requirements, 31; cotton rats, 17–18, **19,** 91; as factor in Red-tail density, 6–7, 8; foot grip in killing prey, 18, **20**; hawk pellets, 21–22; migration in search of, 3–4; rat hunting strategies, 27–28; Red-Wing Blackbirds, 39, 88–91; rodents, 18, 20, 22; snakes, 33; starvation and, 37, 39; stealing from other hawks, 28, **29**; variety, 15, 17
prey density, 39, **41**
prey stealing, 28, **29,** 30–31

quail, 53–54

race characteristics of Red-tailed Hawks, 67–68
railroad track rights-of-way perches, 23–26
raptor pellets, 21–22
raptors: aerial combat, 31; airspace domination by, 45–46; benefits to humans, 23; legislation protecting, 23; Red-winged Blackbird's response to, 90–91; soaring, 47–49; as "vermin," xiii–xiv
rats. *See* cotton rats
rats nests, 20
rattlesnakes, 33
redbud trees, **13**
red cedar tree, **124**
Red-tailed Hawk: age identification, 59–63; diversity of, 55–58, **56–57**; Eastern, 65; Fuertes, 65; Harlan's, **84**; identification of race, 67–68; Northern, 76; personality traits, 51–52; subspecies of, 55–58; as "vermin," xiii–xiv, 46; Western, 79, **80–83**; White, 102–104. *See also* Eastern Red-tailed Hawk; Fuertes Red-tailed Hawk; Harlan's Red-Tail Hawk
Red-winged Blackbirds, 39, 88–91, **90**
Ring-necked Pheasant, 30–31
road kill, 17, 39. *See also* scavenging
rodent bites, 18
rodent damage, 20
rodent populations, 8
rodents. *See* cotton rats
roosting, 13–14
Rough-legged Hawks, 6
rufous morph, **82**

Sam Noble Oklahoma Museum of Natural History, 104
scavenging, **16**, 17, **41**; by injured birds, 39–40
Scissortail Flycatcher, **70**
Sharp-shinned Hawks, 90
Shoveler Duck, **17**
sit-and-watch hunting tactic, 5–6
snakes, 33, 49; bobwhite predation and, 54
soaring, 47–49
Sooner Power Station, **159**
Sooner Reservoir, **145**
starlings, 52
starvation, 37, 39
subspecies of Red-tailed Hawks, 55–58
sumac, **145**

Sutton, George, 23, 65, 67, 68, 85
switchgrass, **146**

tail markings, **129**; of adults, **62**; adult versus juvenile, 62–63; of Harlan's Red-tailed Hawks, 85, **86**; of juveniles, **59**
tallgrass prairies, xiv–xv, **xv**; tree encroachment in, 7
talons, 18, **20**
taxonomy, 55, 67
telegraph poles, **25, 71, 109**
territoriality: in attacks on juveniles, 37; Harlan's Red-tailed Hawk and, 91; local versus migratory populations and, 68, 70–72; of mated pairs, 8; prey density and, 39, **41**; survival imperative and, 33; vocalizations and, 52
thermals, **47,** 49
Tolkien, J. R. R., 51
Tomer, John S., 23
tree encroachment, **7,** 67
Turkey Vultures, 14

ultraviolet light, 8
urbanization, 158
Ute Bluff Road, **159**
utility poles, 43, **44,** 45

vision, 8, **47**
vocalizations, **50,** 51–52; during courtship displays, 71; hunger calls, 39

waterfowl migrations, 3
weather factors: in choice of shelter, **11**; in cotton rat population, 23; in hawk watching, 13; in hunting strategies, 12–13; in migration patterns, 10, 12
Western Red-tailed Hawk, **78,** 79, **80–83**
white Red-tailed Hawks, 102–104, **103, 104**
white-tail deer, 54
Will Rogers Turnpike, 26
wind deflection, **48,** 49
wind generators, **157**
windmills, **118**
windy conditions, 12–13
wing markings: adult versus juvenile, 62–63. *See also* plumage
wing structure. *See* body and wing structure
wintering grounds, xiii, 3–4
wood rats, 20
wrist joints, **123**